We Take Care of Our Own

We Take Care of Our Own

We Take Care of Our Own

Faith, Class, and Politics in the Art of Bruce Springsteen

June Skinner Sawyers
with an afterword by Andre Dubus III

RUTGERS UNIVERSITY PRESS
NEW BRUNSWICK, CAMDEN, AND NEWARK, NEW JERSEY
LONDON AND OXFORD

Rutgers University Press is a department of Rutgers, The State University of New Jersey, one of the leading public research universities in the nation. By publishing worldwide, it furthers the University's mission of dedication to excellence in teaching, scholarship, research, and clinical care.

Library of Congress Cataloging-in-Publication Data

Names: Sawyers, June Skinner, author.
Title: We take care of our own: faith, class, and politics in the art of Bruce Springsteen / June Skinner Sawyers.
Description: New Brunswick: Rutgers University Press, 2024. | Includes bibliographical references and index.
Identifiers: LCCN 2023047847 | ISBN 9781978835702 (paperback) | ISBN 9781978835719 (cloth) | ISBN 9781978835726 (epub) | ISBN 9781978835733 (pdf)
Subjects: LCSH: Springsteen, Bruce. | Springsteen, Bruce—Political and social views. | Springsteen, Bruce—Criticism and interpretation. | Rock music—Social aspects—United States. | Rock music—United States—History and criticism. | BISAC: MUSIC / Individual Composer & Musician | MUSIC / Genres & Styles / Folk & Traditional
Classification: LCC ML420.S77 S304 2024 | DDC 782.42166092—dc23/eng/20231020
LC record available at https://lccn.loc.gov/2023047847

A British Cataloging-in-Publication record for this book is available from the British Library.

Copyright © 2024 by June Skinner Sawyers
All rights reserved

No part of this book may be reproduced or utilized in any form or by any means, electronic or mechanical, or by any information storage and retrieval system, without written permission from the publisher. Please contact Rutgers University Press, 106 Somerset Street, New Brunswick, NJ 08901. The only exception to this prohibition is "fair use" as defined by U.S. copyright law.

All photos are by the author unless otherwise indicated.

References to internet websites (URLs) were accurate at the time of writing. Neither the author nor Rutgers University Press is responsible for URLs that may have expired or changed since the manuscript was prepared.

⊖ The paper used in this publication meets the requirements of the American National Standard for Information Sciences—Permanence of Paper for Printed Library Materials, ANSI Z39.48-1992.

rutgersuniversitypress.org

If a free society cannot help the many who are poor, it cannot save the few who are rich.

—John F. Kennedy

It's a cruel jest to say to a bootless man that he ought to lift himself by his bootstraps.

—Martin Luther King Jr.

Honest critique is a pillar of patriotism.

—Charles M. Blow, *New York Times*

The American government gives the most help to those who need it least.

—Matthew Desmond, *Poverty, by America*

We seek to stay present, even as the ghosts attempt to draw us away.

—Patti Smith, *M Train*

Contents

	Introduction: In the Shadow of Plenty	1
1	Workingman	5
2	A Sense of Place	21
3	Chapter and Verse	33
4	The Good Book	41
5	The Populist Imperative	49
6	Hope and Dreams	61
7	Left Behind	73
8	An Absence of Things	85
9	Jersey Cowboy	95
10	Tomorrows and Yesterdays	113
	Coda: Far beyond Today	117
	Afterword by Andre Dubus III	121
	Acknowledgments	125
	Notes	127
	Selected Bibliography	133
	Index	139

We Take Care of Our Own

Railroad Tracks, Roosevelt Road (Chicago)

Introduction

In the Shadow of Plenty

Without a common good, we are alone, adrift on the frontier.
—Stephen J. Lyons

Bruce Springsteen is a patriot but hardly of the simple-minded, jingoistic variety that some of his critics have painted him out to be over the years. Rather he is a complicated patriot who sees his country through gray-colored glasses. More precisely, in spirit Springsteen is an anachronism, an old-fashioned FDR liberal stuck in twenty-first-century conservative, stripped-down America. He believes Americans should take care of their own at a time when distrust of government is at an all-time high.

Springsteen has been called the rock and roll laureate of the United States, the everyman prophet of the working class. His work unites poetry and politics and class and religion. This most Catholic of artists writes lyrics infused with a strong Catholic streak punctuated by biblical metaphors and messianic warnings. Indeed, Catholicism is to Springsteen what Judaism is to Dylan or Cohen: in a word, inseparable. "Once you're a Catholic, there's no getting out," he joked on the television series *VH1 Storytellers*.

For decades now Springsteen has written about people down on their luck, offering trenchant commentary on various disasters—both manmade and natural—from the 9/11 attacks to the

administration of George W. Bush, the Great Recession, and the improbable election of real estate tycoon/reality TV star turned latter-day Bible salesman Donald Trump. Although social justice issues have always formed an undercurrent of his body of work, his later works in particular indicate a strong predilection for, some would say obsession with, social justice.

Specifically, the characters he sings about in "We Take Care of Our Own," "Jack of All Trades," "Easy Money," "Shackled and Drawn," and "Death to My Hometown"—all from his 2012 release *Wrecking Ball*—condemn government policies that, in his estimation, come up woefully short. In "Shackled and Drawn," for example, Springsteen's narrator could not be more direct. The fat cat bankers—that is, Romney's one percent—live it up, while the "workingman pays the bill." In truth, these sentiments are nothing new.[1]

With Springsteen now in his seventies, another phase of his life has begun. In albums like *Western Stars* and *Letter to You*, Springsteen has turned inward. He still engages with the world but in a different way. Lately, in fact, he has also begun to look at the songs he listened to growing up. Unlike other contemporary singers (such as Rod Stewart), he has turned not to the traditional American songbook but rather to the soul and R&B singers of his youth: the Jackie Wilsons and Jerry Butlers of the world.

For years, at least since 1978's *Darkness on the Edge of Town*, Springsteen's songs have straddled the line between optimism and pessimism. Anger and desperation sometimes yield to hope. But this hope is tempered with a deep-seated sense of loss. It is this precarious tension that exemplifies his best work.

During the first two decades of the twenty-first century this sense of hope has been tethered to an increasingly fragile cord. At a press conference in Paris in early 2012 supporting the release of *Wrecking Ball*, Springsteen expressed his anger in the plainest of terms. "A big promise has been broken," he told the crowd. "You can't have a United States if you are telling some folks that they can't get on the train. There is a cracking point where a society collapses. You can't have a civilization where something is factionalized like this."

In fact, Springsteen has spent a good part of his adult life examining and commenting on the often-considerable gap between American reality and the American Dream, between how life actually is lived and how it should be lived. Springsteen is that twenty-first-century American rarity: a progressive conservative, a conservative liberal. But how did an apolitical working-class boy from a small New Jersey town become the liberal symbol that he is today? In other words, how did Bruce Springsteen, a young man from small-town Freehold, New Jersey, become the Boss, icon of the workingman and workingwoman?

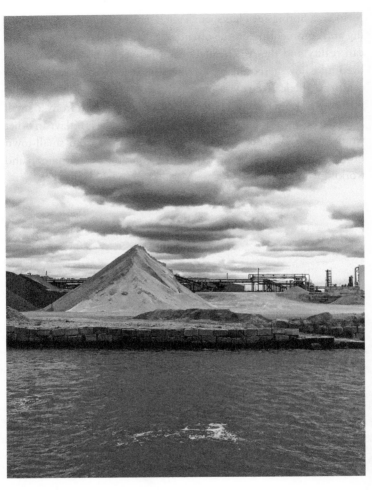

Chemical Valley (Sarnia, Ontario)

CHAPTER 1

Workingman

People don't seem to want to talk about class in America.
—Joyce Carol Oates

Springsteen's growth as an artist has developed slowly over the decades. Back in November 1975, when asked point-blank if he was politically minded or paid attention to world events, he offered a flat, unequivocal "no." Anyone who has followed his career knows that the Springsteen of today is in marked contrast to the skinny New Jersey musician of the late 1960s and early 1970s who played the rowdy bars up and down the Jersey Shore. As a struggling musician, Springsteen was a shy and tongue-tied young man, barely articulate. To paraphrase his own lyrics in "Thunder Road," he spoke not with his voice but with his guitar.

Springsteen's political awareness emerged slowly and organically. He grew up in a working-class New Jersey home that showed little interest in culture or, for that matter, politics. Although he was raised in an apolitical family, he was told as a young boy that he lived in a Democratic household because the Democrats fought for the "working man." But beyond these vague affiliations, he did not examine what being a Democrat actually meant. There was no incentive to get involved in the political process, nor was there any encouragement to consider the effects that the body politic might

have on everyday life. His gregarious mother, Adele, was too busy working as a legal secretary to keep food on the table while his taciturn father, Douglas, was more often than not lost in a drunken, angry haze: livid at a system that he felt kept him stuck in low-paying jobs throughout Springsteen's childhood and young adult life. Adele loved country music and Elvis Presley, but she had another far more significant trait. She handed down to her son a work ethic that earned him the reputation of being the hardest working man, if not in show business—that honor usually was accorded to James Brown—at least in rock.

Ultimately, what raised Springsteen's political consciousness, what elevated his political hackles, was education or, more precisely, *self-education*. He is naturally curious, and the act of learning and the desire to think for himself led him to the life, and career, that he has today. The community college dropout—Springsteen attended Ocean County Community College in Toms River, New Jersey, for two years—became the thinking man's rock star. At the college he studied English and took writing classes, including an advanced composition class where he received an A. At one point he even considered applying for journalism school at Columbia University. As perhaps a precursor to the songs that would later appear on *Nebraska* and other albums, Springsteen, notes his biographer Peter Ames Carlin, composed short stories that "read like dark meditations on a world leeched of humanity." What's more, he was not popular with a school administration that had little patience for his shoulder-length hair and his "odd" taste in clothes so when they asked him to leave, he did so without looking back.

Instead, he moved forward.

Springsteen's first real political association of any kind appears to date back to George McGovern's presidential campaign of 1972. He played a benefit show at the three-hundred-seat Cinema III Theater in Red Bank, New Jersey, to raise money for the South Dakota senator. Apparently, though, he didn't have much patience for the speeches that he heard on the senator's campaign trail. He

later admitted that around then he voted for the first time, presumably for McGovern, and yet he had no real interest in getting involved in politics. (During an interview with *Rolling Stone* in 1984, he told journalist Kurt Loder, but not very convincingly, that he thought he voted for McGovern in 1972.)

His political awakening was a slow process. As a young man he couldn't find Vietnam on a map if his life depended on it. He just knew he didn't want to go to a strange land to die for a war he didn't believe in—and a war that he later felt was a subversion of American ideals, a war that "twisted the country inside out."

Springsteen's earliest work consisted of vaguely autobiographical songs about life along the Jersey Shore. His first albums, *Greetings from Asbury Park, N.J.* and *The Wild, the Innocent & the E Street Shuffle*, were portraits of beach life in rundown New Jersey towns. The themes were the common mainstays of rock and roll: cars, girls, and freedom. Ironically, Springsteen didn't learn to drive until he was twenty-four.[1] Until then, he hitchhiked everywhere he went, which mostly meant the short distance—a total of fifteen to twenty miles—between Asbury Park and Sea Bright or Freehold or Manasquan. And yet even when he couldn't drive, he knew and fully internalized what a car meant. Freedom. Escape. Independence.

The characters in these early songs were unformed young men and women—but mostly men—on the cusp of adulthood unable or unwilling to accept responsibility. The songs depict life on and off the boardwalk—the people with the crazy nicknames whom he knew and the places they hung out in. There is an appealing fluidness to the songs, a sense of looseness and playfulness—essentially sweet in nature—that Springsteen would soon leave behind for a tighter, spare, and more controlled sound. The language on these two albums is distinctive too: unvarnished, dense, and wordy, so many words in fact that looking at the page a listener might have reasonably wondered how the singer was able to keep up with the music. It is as if the songwriter felt he had only one chance to stake his claim in the world and he had better make the best of it by putting down every thought that came into his head. Despite the

inherent life-affirming joyfulness on display, there is an undercurrent of sadness too, and of urgency amid the slacker lifestyle. The listener gets the sense that these characters are just biding their time, like some fleeting summer fling, before seeking a better life elsewhere.

His 1975 breakthrough album, *Born to Run*, deepened the theme of having nowhere to turn. It changed his life and his career, of course; it wasn't until after its release though that Springsteen decided not only to change the way that he wrote—out went the dense language, in came a starker idiom—but also to write about characters facing and confronting adulthood, and their consequences. But *Born to Run* is also a deeply spiritual work, which Springsteen himself has acknowledged. Indeed, a case could be made that the entire album is a religious vision full of seekers, misfits, and outcasts who are continually questioning their values and their faith.

During the period between *Born to Run* and his subsequent album, *Darkness on the Edge of Town*, Springsteen's career was in limbo. For three years his hands were tied; he was entangled in a legal dispute with his manager, Mike Appel, that prevented him from recording. But when he returned to the studio, the songs came pouring out of him. In fact, the release of *Darkness on the Edge of Town* in 1978 was a turning point for Springsteen; he wanted to write about more than just the usual themes—girls and cars—that he was known for. Until *Darkness*, he told his biographer Dave Marsh in 1981, "I didn't think about too many things."

From the opening power chords to the defiant closing line, "Born to Run" is a singular achievement and a great rock anthem. It has been called Springsteen's masterpiece, a rock opera in miniature with everything that such a statement implies. Indeed, it has it all: the Stax Records sound, the vulnerability of a Roy Orbison song, the poetry of Van Morrison. It is for these and other reasons that "Born to Run" is considered by many critics to be the greatest song Springsteen has ever written, period.

Born to Run marked a turning point for Springsteen, recorded during a transitional time in his career, a time between what he was and what he would become. The song itself took six months to complete. At various times, it went through several versions, including one rendition that included strings and a backing choir.

Springsteen wrote the album in a rented cottage on West End Court in West Long Branch, New Jersey. By the spring of 1974, he had already recorded two albums that went nowhere. He knew his record company, Columbia, was growing inpatient. He felt the pressure. He knew he had to produce something that was not only memorable but also commercial. Moreover, in order to do what he wanted to do in the music business, he had to create not only a masterpiece but a *commercial* masterpiece. He had to turn an oxymoron into reality.

Born to Run proved to be transitional from an artistic perspective, too. As Springsteen notes in *Songs*, his characters became "less eccentric . . . they could have been anybody and everybody." The songs, he said, confronted issues of "faith and a searching for answers." Springsteen thought of it as a very personal album.

In other words, this was his last chance, and he couldn't afford to blow it.

After *Born to Run* he began seriously to ponder the fate of his family and friends back home, stuck in a dead-end town in a broken economy. *Darkness on the Edge of Town* was a self-revelatory work of breathtaking maturity, of light and shadow, hope and despair, but also with occasional patches of optimism amid the darkness. Songs such as "Badlands," "Racing in the Street," "The Promised Land," "Factory," "Prove It All Night," and the title cut revealed a level of lyrical depth not evident in Springsteen's previous work as he explored the complicated inner life—and dreams—of his characters and, by extension, the working lives of countless men and women across America. "By the end of *Darkness*," Springsteen wrote in *Songs*, "I'd found my adult voice." He knew what his subject

would be. "I wanted to stay home. I wanted to live here. I wanted to be . . . surrounded by the people that I knew and tell my and their story," he later told former president Barack Obama in *Renegades*.

His next release, *The River*, in 1980, was a double album that revealed both sides of Springsteen: fun Bruce and serious Bruce. During the *River* tour it became apparent that his songwriting style, the style that he had explored on *Darkness*, was deepening once again, turning more introspective as he wrote for the first time about commitment, marriage, and settling down (even though he was not quite ready to do so himself). He also addressed for the first time the troubled relationship with his own father in "Independence Day" ("I guess that we were just too much of the same kind"), maintaining a fragile bond even as they—in the song and in life—go their separate ways. "I grew up in a house where it seems nobody ever talked to each other," he said at the time.

After the *River* tour ended, Springsteen began seeing a therapist, part of a decades-long search of self-discovery. He was spending a great deal of his time by himself, thinking not only of his own dysfunctional family dynamics but also about the depressed economic state of the country during the Reagan era. He began seriously listening to folk and country for the first time and strongly identified with the straightforward country songs and direct language of Hank Williams—simple in vocabulary perhaps but profound in its emotional wallop. I will say more about the symbiotic relationship between Springsteen and country music later.

From these disparate sources emerged what many consider his masterpiece, the acoustic *Nebraska* (1982). With this album he captured the darkening mood of the country, which in turn reminded him of how he felt as a child growing up in New Jersey: in a word, isolated. With just a Gibson J-200 acoustic guitar, an electric guitar, a mandolin, harmonicas, and a glockenspiel, Springsteen recorded the songs of *Nebraska* in a rented ranch house in Colts Neck, New Jersey, creating a shadow world that captured a deep despair, an American hopelessness in an album that went deeper than words.[2] In 1962, writer Michael Harrington had referred to

the Other America, the America of the rural poor and the urban poor. This was the same America Springsteen was singing about but some two decades later. Even though Springsteen did not intend *Nebraska* to be a political statement—he was merely expressing what he was thinking at the time, he has said—critics picked up on its political implications. To Springsteen's way of thinking, the record was supposed to tap into his upbringing, "of the way my childhood felt, the house that I grew up in. I was digging into that," he told BBC producer Mark Hagen in 1999. In particular, the songs recalled the paternal side of his family, capturing "a certain way they spoke, a certain way they approached life."

Springsteen had been down this economic road before. The entire collection of songs on *Nebraska* is an indictment of governmental policies that led, he believed, to economic failure and social malaise. The policies of Reaganomics had a devastating effect on the working class. But the twenty-first century's Great Recession was equally bad, if not worse. Studies indicated that the Great Recession has been especially harmful to male employment rates, prompting *Newsweek* in April 2011 to dub it a "Mancession." The victims of this Mancession could easily be construed as characters in many of Springsteen's songs. The Great Recession, though, affected communities across the country and in places where people thought they were immune to the up-and-down vagaries of the economic winds. In places like Janesville, Wisconsin, for example, workers were shocked when the local General Motors plant shut down. People expected it to last forever. In more recent years, sociologists and scholars have suggested that women and minorities also suffered terribly during the Great Recession and continue to do so at disproportionate rates. According to the Bureau of Labor Statistics, women were also affected, earning 83 percent of what men did in 2021.

But the male labor force had been in a free fall for generations. "One-fifth of men in their prime working ages are out of the labor force," wrote David Brooks. The trend has only worsened since the Great Recession and the COVID-19 pandemic. As Brooks pointed

out, over the years there had been a shift in the definition of dignity. To Springsteen, work and dignity go hand in hand. Brooks's description of a particular type of man describes Springsteen's father, perfectly. "Many men," he asserted, "were raised with a certain image of male dignity, which emphasized autonomy, reticence, ruggedness, invulnerability, and the competitive virtues. Now, thanks to a communications economy, they find themselves in a world that values expressiveness, interpersonal ease, vulnerability, and the cooperative virtues."

Conditions worsened during the COVID-19 pandemic. According to *Time* magazine, the runaway inflation that emerged from the pandemic broke the backs—and the bank accounts—of countless middle-class Americans. Although many were able to add to their savings and countless benefited from stimulus checks and a pause of federal student loan payments, the respite was temporary. As the *Times*' reporters noted, "Being middle class in America isn't only about how much you make; it's also about what you can buy with that money." Younger generations of Americans may make more money than their parents and grandparents once did, but their hard-earned cash buys less. Many still can't afford to buy a home, the traditional ambition and status symbol of the American Dream. More than 70 percent of people in the thirty-five- to forty-four-year-old age group owned a home in 1980, according to the Urban Institute. Compare that to fewer than 60 percent by 2018.

The middle class was feeling not only left out but, to borrow a popular term, left behind.

Another example of the worsening malaise is the shrinking of middle-class neighborhoods nationwide, which in turn reflects a broader trend of increasing income inequality. In 2022, *New York Times* reporters Sophie Kasakove and Robert Gebeloff noted that the population of families making more than $100,000 has grown faster than other groups, while the number of families earning less than $40,000 has increased at twice the rate as middle-class families. The end result is that working-class workers cannot afford to work in the city they work in. Economists refer to this trend as a

form of economic segregation. Michael Street, a union electrician who lives outside of Nashville, told the *Times* reporters that "either you're poor, or you're rich. Middle class is kind of phasing out. Either you have a lot of money, or you're just barely getting by."

In post-pandemic America the effects are everywhere: the rise in the number of families living in their cars; the millions of people without decent health insurance even as the main features of "Obamacare" sink in; food banks cropping up in suburban neighborhoods; the ever-widening gap between rich and poor, between the 1 percent and the rest of the 99 percent, a gap that has grown since the early 1970s. As of this writing, the U.S. income gap is at its highest level since the Great Depression. According to sociologist Matthew Desmond, one in eight Americans lives in poverty.

Springsteen's great 2012 album of social injustice, *Wrecking Ball*, addressed many of these issues. *Wrecking Ball* is a collection of plainspoken, populist, Occupy-movement-style protest songs and working-class anthems with a rock and roll heart inspired by the Great Recession in much the same way that Reaganomics inspired *Nebraska*. It contains a profusion of musical styles (sampling, hip-hop, looping, Irish jigs, gospel choirs), while themes of income inequality and the failure of the American Dream echo strongly in its lyrics. The rousing title cut uses the demolition of Giants Stadium in New Jersey as a metaphor for the destruction of American values and ideals over a thirty-year span. Here Springsteen offers a bleak portrait of a nation that has lost its way and where there is less opportunity for fewer and fewer people. His lyrics are rooted in truth and cold, hard statistics. In 2012, the year *Wrecking Ball* was released, the Pew Research Study published "The Lost Decade of the Middle Class." Since 2000, noted the glum report, "the middle class has shrunk in size, fallen backward in income and wealth, and shed some—but by no means all—of its characteristic faith in the future." To place Springsteen's album in perspective, consider the difference in pay between a 1950s CEO and the modern equivalent. A typical worker at Walmart earns less than $25,000 a year, while the company's chief executive was paid more than

$23 million in 2012, cites Thomas Piketty in *Capital in the Twenty-First Century*.

Wrecking Ball also represents the epitome of the Springsteen ethos, which can be summed up in one sentence: "Remember, nobody wins unless everybody wins." Compare that line with Jesus's admonition to his followers in Luke 3:11:

> Whoever has two coats must share with anyone who has none;
> and whoever has food must do likewise.

These simple words form the essence of Christian goodwill generally and of the Catholic demand to help those less fortunate specifically. It sums up too Springsteen's attitude toward government. It embodies his love of fairness and his passion for justice. It is there in the deeply ironic "We Take Care of Our Own." Although hardly the best song on *Wrecking Ball*, it is its heart. The song references, for example, Hurricane Katrina ("from the shotgun shack to the Super Dome") in its litany of complaints and failures. The singer knows that this is clearly not the case in twenty-first-century America ("There ain't no help, the cavalry stayed home"). On the contrary, in Great Recession–era America the people are on their own, left to their own devices. The social contract, the covenant of an America where everyone helps one another from "sea to shining sea," Springsteen sings, has been broken. America, he contends, has reneged on its promise to look after its own citizenry. American institutions have failed the Americans they are supposed to be looking after.

In 2012, former Republican Speaker of the House and vice presidential nominee Paul Ryan came up with a different catchphrase, "the American Idea." His approach to poverty was a variation of the "pull yourself up by your bootstraps" philosophy and his "we're in it together" speeches. In *Bootstrapped*, Alissa Quart condemns the myth of the self-made man and the "fantasy of self-sufficiency" that perpetuates the every-man-for-himself ethos of American society.[3]

According to writer Amy Goldstein, Ryan believed that people who needed help should look not to New Deal–like government intervention but rather to their local community. But what happens when the community itself is down on its collective luck? When members of the community can't help themselves, never mind anyone else? Significantly, during the 2012 election, Ryan's own Janesville ward voted against him. Equally significant, four years later, Wisconsin as a whole turned Republican for the first time in thirty-two years even as Janesville retained its Democratic core. But the switch between political parties might have had to do more with working-class resentment than with governmental policies.

What Springsteen is essentially espousing is a twenty-first-century European mindset, or, to put it in an American framework, a mid-twentieth-century, Roosevelt-era philosophy. Years later and on various occasions he was asked about his political beliefs. Refusing to use left or right terminology, instead, he suggested that full employment, health care, and education for all, decent housing, day care for children, a transparent government—all conservative ideas, in his estimation—is a reasonable expectation for the American government to provide its citizens. In Springsteen's America, no one should be left behind. "A dignified decent living is not too much to ask," he writes in *Born to Run*.

But he went even further by insisting all these ideas are essentially Jesus's teachings, which, in twenty-first-century America, some consider a radical thought.

The core themes that are prominent in Springsteen's entire body of work include

- community
- compassion
- dignity
- fairness
- faith
- honor
- justice

- loyalty
- patriotism
- rule of law

Even though separated by many years, *Nebraska* and *Darkness, The Ghost of Tom Joad*, and *Wrecking Ball* should be considered as a thematic set piece (his more recent work is also a set piece but of a far different variety, as we shall later see). The albums' predecessors can partly be traced back to a famous literary work, James Agee's 1941 *Let Us Now Praise Famous Men*.

Agee's study of Alabama tenant farmers during the Great Depression (with photographs by Walker Evans) is the aural equivalent of many songs from the Springsteen canon. At a time when few contemporary writers (with the possible exceptions of David Shipler, Barbara Ehrenreich, and, most recently, Matthew Desmond and Alissa Quart) have devoted real effort and study to economic conditions in Great Recession America, Springsteen has continued his virtually one-man excavation of the working man and woman. As Springsteen wrote in his memoir, *Born to Run*, "I never saw a man leave a house in a jacket and tie unless it was Sunday or he was in trouble."

But Springsteen is not entirely alone in his exploration of working-class angst and struggle. A handful of contemporary popular musicians from across the globe also have mined the same topic, including Steve Earle, Merle Haggard, U2, Green Day, Billy Bragg, the Chicks, Iris DeMent, Dick Gaughan, and the up-and-coming English rocker Sam Fender. (Dylan is in a category all his own.) For a decade or so, English punk rockers the Clash wrote songs with a strong left-wing ideology (lead singer Joe Strummer was a socialist).

In recent years, artists ranging from Tracy Chapman to John Mellencamp to Jason Isbell have written topical songs commenting on the struggles of the working class and marginalized communities. These types of songs still strike a chord. In 2023, country

singer Luke Combs had a surprise hit with his rendition of Chapman's classic "Fast Car." In the same year, Oliver Anthony made a splash with "Rich Men North of Richmond," an angry anti-government country-folk ballad about the devastating effects of high taxes and high inflation on the working class. It became the biggest viral sensation of 2023 and a favorite of conservative pundits.

Like Springsteen, singer and occasional actor, Alabama-born Jason Isbell is an empathetic songwriter who writes character-driven songs: adult songs about consequences and taking responsibility that focus on people struggling with their own personal demons as well as grappling with societal problems. In "Save the World," on the 2023 album, *Weathervanes*, which he recorded with his band the 400 Unit, he laments with a resigned sigh that somebody "shot up a classroom again" while in "White Beretta," the narrator regrets a decision he made years earlier as a younger man. (The CD comes with a cheeky message that appears only on the cellophane—it's easy to miss when unwrapping: "Life and death songs played for and by grown ass people.")

Other writers have written superbly about the Great Recession: George Packer and Barbara Garson come to mind. Anyone who wants to place Springsteen's lyrics in contemporary perspective could do worse than read the works of these authors. "The leading symbol of recent economic distress is an abandoned house in a brand-new subdivision, with telltale weeds pushing up through cracks in the driveway," writes Packer. Citizens of the Great Recession don't expect help from anyone, whether the government or the banks.

According to Packer's 2013 *The Unwinding: An Inner History of the New America*, members of the working class do not want to rock the boat. For the most part, they were not about to join the Occupy Wall Street movement, he notes, referring to the short-lived grassroots international protest movement against income inequality. They may have wanted acknowledgment and recognition for the

dire straits they found themselves in, but more than anything they simply wanted to work. They wanted to work at a time when not only manufacturing but also clerical and managerial jobs were losing ground, and fast. An unemployed boat salesman told Packer, "Imagine getting up every day and not having a purpose. You're not working your self-worth goes down the toilet. You don't interact with people. You stay in your house. You don't want to answer the phone. It isolates you."

These sentiments vividly recall Springsteen's own words when he was writing the songs on *Nebraska*. Springsteen was dislocated not really geographically—Colts Neck is less than ten miles from Freehold after all—but emotionally. "Nebraska," the song and the album, evoked solitary prairie figures in the way that songwriter Jimmy Webb evoked the wide-open plains in his gorgeous but melancholy pop songs. Springsteen discussed with Mark Hagen feeling disconnected: "I just wasn't any good. . . . There are things that make sense of life for people: their friends, the work they do, your community, your relationship with your partner. What if you lose those things, then what are you left with?"

In *The Lonely City* exquisite English writer Olivia Laing describes the often-tortuous existence of loneliness and aloneness when she moved to New York City in her mid-thirties. "My life felt empty and unreal and I was embarrassed about its thinness, the way one might be embarrassed about wearing a stained of threadbare piece of clothing," she wrote. Worse, she felt like she was "in danger of vanishing."

A contemporary literary accompaniment to Springsteen's music—indeed, the twenty-first-century equivalent to Agee and Evans—is Dale Maharidge's 2011 *Someplace Like America: Tales from the New Great Depression*, with photographs by Michael S. Williamson (Springsteen wrote the foreword to the 2013 edition). Maharidge and Williamson assembled an earlier and similarly themed book, *Journey to Nowhere*, in 1996, to which Springsteen also contributed. Thematically, both books are visual accompaniments to

Nebraska, *Tom Joad*, and *Wrecking Ball*. Years later, in 2020, just when he thought he had said everything there was to say on the subject, Maharidge returned to the social justice theme in *F**ked at Birth: Recalibrating the American Dream for the 2020s*, in his part memoir, part investigative reporting book on class and privilege in Trump's America.

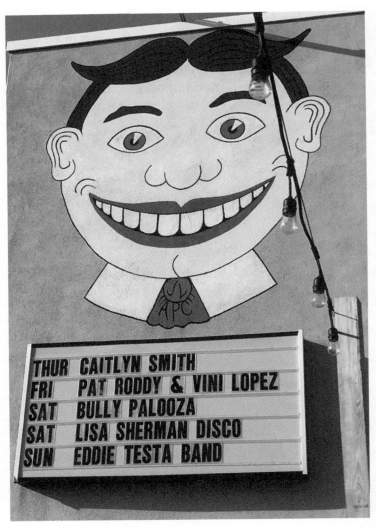

Tillie at the Wonder Bar (Asbury Park, New Jersey)

CHAPTER 2

A Sense of Place

What Liverpool is to the Beatles, Asbury Park is to Bruce Springsteen. The song that encapsulates so beautifully the enigma of Asbury begins with the strum of an acoustic guitar. It captures a moment as fleeting as a sunny day along the Jersey Shore. "4th of July, Asbury Park (Sandy)" is Springsteen's musical love letter to his adopted hometown, that faded, backwater, working-class resort town that, despite already being down on its luck, miraculously gave *him* hope. It was his first taste of the Promised Land. Ironically, an earlier famous son of Asbury Park, the novelist Stephen Crane, saw here not hope but despair and hypocrisy. Springsteen a century later saw something else amid the beautiful ruins—a sense of purpose and meaning.

"Sandy" is a love song about two Jersey tramps, drifters on the boardwalk and drifters in life, who manage to survive in a gritty yet somehow still fairy-tale-like setting of amusement parks, penny arcades, and sandy beaches. Jimmy Guterman has called "Sandy" "a warm tale of failure"—in this case, failure to get the girl, failure to keep a job, failure even to enjoy a simple carnival ride (he gets his shirt caught on a tilt-a-whirl) without something going wrong.

Tramps like us. . . .

The unofficial mascot of Asbury Park is Tillie.
Tillie is a nod to George Tilyou.

Riding Down Kingsley

Riding down Kingsley
a cold spring evening
the ocean on the right
Tillie's beaming face on the left
seems somehow surreal
the town so different now
from the Little Eden
when he cruised these streets
living his carnival life
in the shadow of the amusement park
his shirt getting caught
on the tilt-a-whirl
playing shot and beer clubs
and sleeping on the beach
during an idyllic endless summer
with all the time in the world.
On the boardwalk
Madame Marie
still predicts fortunes
or at least her grandchildren
for new generations to come
surrounded by boutique hotels and
luxury high-rises. Visitors hope
for a fleeting glimpse of their
phantom singer at the Stone Pony perhaps
or the Wonder Bar. Tonight a ghost
of Asbury past appears, his voice still supple
and soulful as he pummels the drums
like a mad dog
the familiar sounds of "Jersey Girl"
washing up
on the shore.

—June Skinner Sawyers

George Cornelius Tilyou was an American entrepreneur and showman. Today he is best known as the founder of Coney Island's Steeplechase Park, an amusement park that opened in 1897. The tower of the famous Parachute Jump is the only part of the original Steeplechase that still stands. Significantly, for our purposes, Steeplechase Park's icon was a funny face logo: the image of a man with a broad, toothy smile, his hair parted neatly in the middle, that would become the face of Tillie, or at least an approximation of it.[1]

In 1914, Tilyou also opened a branch of Steeplechase in Asbury Park on Ocean Avenue. It took over most of a city block and featured a roller coaster, a dance hall, a boat-powered ghost ride, and live performers, including a "freak" show, but after it was badly damaged in a 1940 fire, it shut down. Around the same time, Palace Amusements opened in Asbury. It featured similar forms of entertainment: carousels, fun houses, and rides. Palace owners Edward Lange and Zimel Resnik hired Leslie Worth Thomas to paint two Tillies on its façade. This is Springsteen's Tillie, the Tillie that was featured on T-shirts during the E Street Band's 1973 tour and on *Tunnel of Love*. Springsteen also mentioned the Palace on several songs: "4th of July (Sandy)," "Born to Run," and "Tunnel of Love." When the Palace building was demolished in 2004, one of the Tillies was saved and placed in storage. Keansburg, New Jersey, artist Leslie Steigelman painted another Tillie on the side of the Wonder Bar, which remains to this day. In a way the story of Asbury Park is the story of America in microcosm or at least the part of America that has fallen on tough times and struggles to reinvent itself. One can see why Springsteen fell in love with its faded charm so easily. Did he see in its roughness a part of himself? Did the fact that the town once held out so much promise resonate with him?

Daniel Wolff is a journalist and a poet and a biographer. With the publication of the wonderful *Fourth of July, Asbury Park: A History of the Promised Land* in 2005 and the revised and expanded edition in 2022, he also could be considered the unofficial biographer of Asbury Park. He believes that the city can—and does—represent American history. What's more, in the

Springsteen on Broadway, Walter Kerr Theatre (New York). Photo by Theresa Albini.

> I come from a boardwalk town where almost everything is tinged with a bit of fraud. So am I.
> —Bruce Springsteen, *Born to Run*

He has called himself a fraud and laughed about it, the workingman who never worked a day in his life—aside from the occasional

odd job of painting houses, tarring roofs, and doing some cheap lawn work—until he took the stage on Broadway. The irony is profound. Doug Springsteen was a factory man; his son sung about the factory life from a distance. He took his father's story from the gritty small-town streets of New Jersey to the bright lights of Broadway.

He walks onto the almost empty stage alone, with nothing but his guitar and a baggage full of memories. The words fall easily from his mouth flowing like a river toward the Jersey Shore. His fingers touch the strings of the instrument that made him feel alive—that gave him purpose. When he had no reason to get up in the morning the guitar was there, and he soon learned how to make it talk. It takes a brave soul to reveal deep secrets every night in front of hundreds of rank strangers, but for weeks and months on end that's what he did, punching a clock on Broadway—his first real job, he said—swapping stories, sharing songs about fathers and sons, about mothers and sons growing up and growing older: love, faith, and death and everything else in between.

"My parents' struggles, it's the *subject* of my life," Springsteen told the *New Yorker*'s David Remnick. He turned his family's troubles into poetry and, in turn, gave himself purpose. Without a proper father figure growing up, though, he felt rudderless. "I was pretty invisible, and there was a lot of pain in that invisibility," he told Barack Obama in *Renegades*.

Springsteen on Broadway was a revelatory production on many levels, even for those who read the memoir, *Born to Run*, that it was based on. There is something about hearing the words directly from the person himself rather than reading them on the pages of a book or on a computer screen. There's something about the directness of it as if the performer—Springsteen—is speaking directly to you—a member of the audience. Is this why I heard so many people cry at the Walter Kerr Theatre that autumn night when he was describing the fraught and complicated but ultimately loving relationship he had with his father?

town's up-and-down history he senses too the "shape and feel of rock & roll." Rock and roll, he writes, "keeps jumping to what moves us, hurrying to the next climax, deliberately repeating itself as it tries to get and keep our attention."

Asbury Park began life as a religious community, much like its neighbor to the south, Ocean Grove. Its origins date back to the late nineteenth century. In 1870, New York brush manufacturer James A. Bradley bought five hundred acres along the Jersey Shore for approximately $90,000 and a year later founded a town named after Francis Asbury, considered the father of American Methodism and the first Methodist bishop in the United States. Thus, many of Asbury's street names—Kingsley, Webb, Cookman—are named after Protestant ministers. Bradley envisioned Asbury Park as a moral community, a dream city populated by moral, upright citizens. Asbury Park was not meant to be Anywhere, USA. It was intended to be heaven on earth.

Thus, it was Bradley who is responsible for the broad boulevards and the promenade next to the sea (called appropriately enough Ocean Avenue). The large Victorian homes with mansard roofs and wraparound porches that remain today owe a lot to Bradley's vision of his seaside Promised Land. Bradley was also responsible for building the beachfront and the soon-to-be-famous boardwalk lined by hotel after hotel.

During its heyday at its pre–World War II peak, Asbury Park boasted more than two hundred hotels and boarding houses, many of them set back from the beach. Its summer population often swelled to as much as 50,000 people (it had only 3,000 year-round residents) at the time. In the early 1880s, young women in their flowing, long dresses and men in their top hats promenaded along the boardwalk. Asbury's layout was inspired by European cities with their leafy parks, tranquil lakes, and broad avenues leading down to the sea. Alas, Asbury was the victim of its own success, becoming in the end an oxymoron: a religious resort town. Something had to give.

During the postwar years, Asbury's middle class began moving out to the suburbs or further down the coast, a shift that was made more accessible by the opening of the Garden State Parkway in 1955. Shopping malls lured businesses out of town. Adding insult to injury, people who used to flock to the Shore chose instead far-flung hot-weather resorts in Sun Belt states like Florida and Arizona. By the 1960s and 1970s, the well-to-do were replaced by hippies, rockers, bikers, and other assorted counterculture figures.

Springsteen's Asbury was not Bradley's Asbury. By the time Springsteen arrived, Asbury was down on its luck, a former Jersey resort town fading fast. And yet even as far back as 1892, tramps and outcasts haunted the Shore, perhaps none more than Stephen Crane. A part-time reporter, the cigarette-smoking Crane walked up and down the boardwalk, taking his sweetheart to the Kingsley Avenue merry-go-round with its calliope music drifting out to shore, if not quite falling to the ground.

Meanwhile, on May 19, 1969, in Springsteen's hometown, the city fathers of Freehold, New Jersey, canceled a Black unity parade because ostensibly they did not want it to compete with the town's traditional Memorial Day parade. By this time, though, in the town's fraught history, racial tensions were already running high. The decision was a fateful and regrettable one for it triggered a rampage by frustrated Black youth who stormed through the downtown area, throwing rocks at store windows and generally raising havoc. Later that night a carload of white youth pulled alongside a car of Black youth and fired a shotgun blast in the direction of the backseat. The victims, Dean Lewis, sixteen, and Leroy Kinsey Jr., nineteen, suffered wounds to the face and neck. Although none of the injuries were fatal, Lewis did lose an eye.

At the time of the Freehold riots Springsteen was living in Asbury Park, writes Wolff, "in a surfboard factory on the edge of town" and playing in a heavy-metal band called Steel Mill, packing them in at places like the Sunshine In, a short distance from the boardwalk. For even though Asbury Park was a ghost of its former self, the music, and specifically the rock and roll, still attracted a crowd. Clubs like

the Student Prince and later the Stone Pony, an Asbury Park stalwart, were packed.

But Steel Mill wasn't enough for Springsteen. He had other ideas, more ambitious musical aspirations. Inspired by Van Morrison's funky His Band and the Street Choir, Springsteen had visions of forming a new band—one that combined his love of soul music with rock. It would be an integrated band, a bold and risky move in racially tense Asbury Park. The new band didn't last long though—finances got in the way. So, by the winter of 1971 Springsteen was living above an abandoned beauty salon on Cookman Avenue in the heart of Asbury. It was here where he wrote the songs that appeared on *Greetings*.

And it was here where he created the community of musicians and fans who flocked to his shows along the Jersey Shore, where Springsteen and his band would sleep on the beach at night, listening to the roar of the Atlantic waves and dreaming of better days ahead.

Springsteen has often said that music saved his life. Music also cultivated a sense of community—the music and community he created in Asbury Park—that made him feel part of something greater than himself. Springsteen's situation is not unique, of course. Music has saved countless lives. In his memoir *Born to Run*, Springsteen compared music to a repair shop and himself to a "repair man." He considers what he does as simply doing his job: he approaches his work as would any ordinary working-class man or woman. In 2012, during an interview with the *New Yorker*'s David Remnick, he referred to the entire E Street Band as "repairmen," adding "[I]f I repair a little of myself, I'll repair a little of you." Singer-songwriter Mary Gauthier also believes songs can save lives, but more importantly she believes songs can save the human heart. "Songs have the power to repair hearts and heal souls," she writes in *Saved by a Song*.

Springsteen performs in front of hundreds of thousands of people on a typical tour. Sure, he makes recordings that bring in huge amounts of money, but at the end of the day music is still, to him,

just a job. He puts on his working clothes—his uniform, as he calls it, boots, work shirt, jeans—before going on stage and does what he is paid to do. Perform. And it serves a purpose: it may bring joy to millions of people around the world but it makes him feel *useful*. "My costume is my work shirt.... I could have put on [a] paisley shirt or [a] sequined jacket... but I chose the work shirt." By donning the clothes usually associated with the typical workingman or woman, Springsteen effectively is taking on the persona of his own father. And as he has made clear in numerous interviews, he intentionally writes from the perspective of what happens when the breadwinner is no longer able to provide for his family. His father struggled to find work throughout Springsteen's life. "My dad had a very difficult life," he said. "I've always felt like I'm seeking his revenge."

Springsteen may have felt like an outsider growing up in Freehold, but Springsteens have deep roots in the Jersey soil. (The name is a combination of the Dutch words "spring" and "steen," the latter meaning "stone.") Springsteen is so associated with the Garden State that, at one point, safety messages on New Jersey highways warned drivers to "Slow Down. This Ain't Thunder Road." Even drivers who weren't aware of Springsteen's music—who didn't know "Born to Run" from "Born in the USA"—would still have recognized the reference. Either way, there have been Springsteens in New Jersey since the seventeenth century. During the Revolutionary War, John Springsteen served as a private in the Monmouth County militia. Alexander Springsteen joined the Union Army in 1862 and served as a private with the New Jersey Infantry. Springsteen's great-grandfather was called "the Dutchman," Douglas, his father, "Dutch."

"Dutch" Springsteen quit school at sixteen and went to work at the Karagheusian Rug Mill as a floor boy. He later worked a variety of other jobs: at the Nescafe factory, on the Ford assembly line, as a truck driver, as a guard at the Freehold jail. When he came home he sealed himself off from the rest of the family. "He was simply an unknowable man," Springsteen told Barack Obama in *Renegades*, "with a great penchant for secrecy." The place where he seemed most at home was at the neighborhood tavern, surrounded

by his fellow drinkers and mostly alone with his thoughts. The tavern was a refuge. "When you walked through barroom doors in my hometown," Springsteen writes in his memoir, "you entered the mystical realm of men."

Freehold was a town of two-family houses, with neat yards and very few expectations. "In Freehold," wrote Joseph Dalton in *Rolling Stone*, "you're expected to go to work instead of college, to make Scotch tape for 3M or instant coffee for Nescafe, and you weren't expected to make a lot of noise about it. Which is what Douglas Springsteen did, coming home from jobs as a factory worker or prison guard or bus driver to sit in his kitchen and think about the world." The mill was the pride of Freehold—the Supreme Court building and Radio City Music Hall were both clients. But by the time Bruce Springsteen was about to graduate from high school, the mill was experiencing economic woes. (The rug mill closed in 1964 after being in business for sixty years.)

The economic troubles of the town affected Springsteen himself. He told Obama he grew up in a place where expectations were low or nonexistent. "I knew no one who had ever been on an airplane. Kids in the neighborhood, we were like lost tribes . . . all this was outside of the bonds of your experience. And you just took it in stride."

Despite his fame and fortune, Springsteen still carries the childhood scars from Freehold with him. He writes from the perspective of the disaffected, the dispossessed, and the perennial outsider but never, he has emphasized, the outlaw. Significantly, Springsteen is not a radical who wants to destroy the system. On the contrary, he is a conservative at heart, in the best and most humane sense of the word.

French economist Thomas Piketty in his 2014 book *Capital in the Twenty-First Century* asserted that the level of inequality in the United States today is "probably higher than in any other society at any time in the past, anywhere in the world." Almost a decade later, conditions haven't changed much. If anything, they have worsened.

In 2023, sociologist Matthew Desmond wrote in *Poverty, by America* that "if America's poor founded a country . . . [it] would have a bigger population than Australia or Venezuela." By all accounts income inequality has risen to levels not seen since the Great Depression. In fact, the United States is an increasingly segregated, class-conscious society. According to recent studies, America has less social mobility than most advanced countries.[2] In 2017, Jessica Bruder in *Nomadland* maintained that the United States "has the most unequal society of all developed nations. America's level of inequality is comparable to Russia, China, Argentina, and the war-torn Democratic Republic of the Congo." The reasons vary, depending on which party politics one ascribes to. On the one hand, Democrats maintain the affluent are "choking off" opportunity. On the other hand, Republicans contend that the problem lies with big government that eats up profits. Either way, the end result is a stubborn polarization with both sides of the political spectrum demonizing each other.

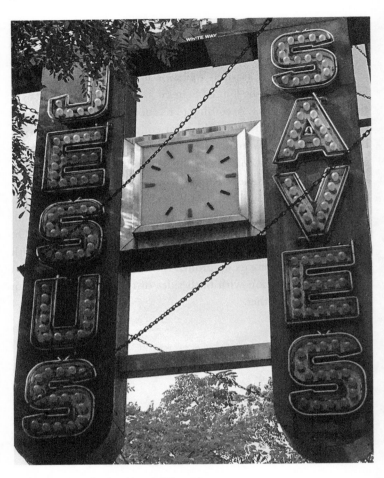

Jesus Saves, Philadelphia Church (Chicago)

CHAPTER 3

Chapter and Verse

Flannery O'Connor, the devout Catholic raised in the largely Protestant Bible Belt, wrote Christ-haunted stories. It could equally be said that Springsteen, a lapsed Catholic, writes songs that have deep emotional connections to the American South. Some of his best songs are steeped in the redemptive imagery of Jesus and his disciples, from "Jesus Was an Only Son" on *Devils & Dust* to "Rocky Ground" on *Wrecking Ball*.

Springsteen attended Catholic school during his formative years and was raised on a steady diet of rituals and incense. His Jesus songs, if I can use that phrase here, also include "Jack of All Trades," in which the protagonist invokes the Social Gospel, where, in a perfect world, "we'll start caring for each other / like Jesus said that we might" while also advocating a bit of rough redistributive justice ("if I had me a gun, I'd find the bastards and shoot 'em on sight").

Springsteen's characters may live in a tragic world, surrounded by suffering and pain, but there is always hope, a glimpse of it anyway even though it may be hard-fought: "there's grace all around you." In his view, being an adult means not knowing all the answers but being able to live with the uncertainty.

A line from *Wrecking Ball*'s "Shackled and Drawn" echoes the Carter Family song "Worried Man Blues." In that country classic a man lies down to sleep by the river and wakes up in chains. In

Springsteen's song a poor man wonders what he is supposed to do in a "world gone wrong." He wakes up in the morning "shackled and drawn," trapped in an existential hell not of his own making but uncertain of how to escape: "A gambling man may roll the dice," he offers, "but the working man can't take the chance but ends up instead paying the bill." Meanwhile, life is easy "up on banker's hill," but down here among the 99 percent, Springsteen sings, we're all "shackled and drawn."

What's a poor boy to do but keep singing his song?

Years earlier, in 1984, Springsteen wrote another song about the fraying of the social fabric in small-town America. In "My Hometown" the shops along Main Street are empty; the textile mills have shut down.

> Foreman says these jobs are going boys,
> And they ain't coming back.

When Springsteen wrote these words the small businesses that once formed the backbone of American industry were being replaced by national franchises run by international conglomerates. Today, the effects of globalization are ongoing and well documented.

The partly autobiographical "My Hometown" chronicles some of the hardships that he experienced while growing up in Freehold: the racial tensions, the closing of the rug mill, and the flight of downtown merchants to suburban shopping malls, things that plagued towns and cities throughout the country, particularly during the Reagan era. The song is elegiac. The singer, a fictional version of Springsteen himself, mourns the death of a way of life, the closing of the town's major source of income—a textile mill—and the subsequent vacant stores and boarded-up windows that dot the town's Main Street.

In many ways "My Hometown" is the unofficial anthem of Freehold. He used to think that once he left Freehold, he would never return. But as he got older, he would visit his old hometown and

meet up with old friends. He realized that no matter how far he traveled he would always carry a bit of Freehold with him.

I was raised Catholic so Jesus was my de facto homeboy.
—Bruce Springsteen, *Devils & Dust* tour, 2005

Springsteen always has had a complicated relationship with the Catholic Church. And yet despite his ambivalence, his Catholic upbringing has affected and continues to affect his worldview even as his feelings have changed, developed, and matured over the years. Although Springsteen was Catholic bred and born, as an adult he turned his back on the dogma of the Church, even though his songs continue to be laced with Catholic imagery. Springsteen's language comes straight out of the Bible, the gospel, and the rituals of the Catholic Church. Indeed, Catholic metaphors and similes have appeared in Springsteen's lyrics virtually since he began writing songs. From his debut album in 1973 up to the present day, his lyrics offer example after example of descriptions culled from both the Old Testament and the New. He uses characters and stories from the Bible—Cain and Abel, Jonah and the whale, and even Jesus himself—to comment on contemporary life in the United States.

In truth, Springsteen's Catholic education instilled fear in him. That fear as well as feelings of awe stayed with him as an adult and found expression in his songs. The Catholic faith has informed and continues to inform his artistic vision. But his disdain for dogmatism runs deep—always has and presumably always will. Springsteen's Catholicism is freighted with a symbolism not tied down by doctrine. It comes from a punishing Catholic elementary school education where kindness and grace were in short supply. Springsteen has described over and over again how mean-spirited the nuns were at St. Rose of Lima in his hometown of Freehold, New Jersey. He was a self-proclaimed outsider whom nobody understood—certainly not the religious staff.

"I hated school," he said as far back as 1978. His experiences have led him to issue a cautionary warning to contemporary educators. "My advice to teachers today is to keep your eyes on the ones who don't fit in. Those are the ones that can think out of the box. You'll never know where they'll be going." At school, he was socially awkward, reserved, a loner—and poor. When he was eight years old, as the story goes, one particularly cruel nun stuffed his small body into a garbage can because, she told him, "that's what you were worth." His crime? Not reciting Latin properly.[1] Given his outsider status and feeling isolated at home—despite his mother's best attempts to provide a loving and supportive atmosphere—it seemed that Springsteen had the future makings of a juvenile delinquent. But a savior arrived from the streets of Memphis in the very human form of Elvis Presley. When the nine-year-old Springsteen saw Elvis on *The Ed Sullivan Show*, his world changed. He didn't know it yet, but his future had also changed. He looked at his mother, who was watching the program with him, and declared, "I wanna be just . . . like . . . that."

Years later, as Springsteen became a father himself, it is clear from reading his own words that he identified with and even appreciated the rituals of the Church, even as he didn't quite believe the teachings. He later discussed this aspect of Catholicism with fellow musician Elvis Costello, an Irish Catholic from Liverpool, on the television program *Spectacle* in 2010.

"There is the religious element of I need to be transformed . . . into something other than what you are. . . . It's a funny thing . . . I look back and I've got a lot of harsh memories of my childhood," he told Costello. "It was a very strict religion at the time. . . . But at the same time, it was an epic canvas and it gave you a sense of revelation, retribution, perdition, bliss, ecstasy. When you think that that was being presented to you as a 5 or 6 year old child and I think I've been trying to write my way out of it ever since."

Springsteen's Catholicism is a potent brand of working-class, urban, and ethnic (mostly Italian and Irish), a brash type of streetcorner Catholicism that anyone familiar with the films of Martin

Scorsese will instantly recognize (when writing about Dion DiMucci in his 2022 *Philosophy of Modern Song*, Bob Dylan referred to Springsteen as a "fellow Italo-rocker"). The younger Springsteen, in particular, adopted a tough onstage persona—think of the bravado of "It's Hard to Be a Saint in the City" on *Greetings*—that partly recycled Presley and Dylan with a touch of Marlon Brando but with a strong Jersey flavor.

Springsteen has also written about his Irish Catholic ancestry. In his memoir he noted that the older he gets the more he looks like his father—his Irish side. He has also explored his Irishness in both original songs ("Death to My Hometown" on *Wrecking Ball*) and covers ("Mrs. McGrath" on *The Seeger Sessions*). He has described his paternal grandparents as being "old-school Irish people." He told Barack Obama that they were "provincial: quite backward, country people. We all lived in one house: my parents, my grandparents, and myself."

Either way, Springsteen's attitude toward the Church has evolved over the decades, from irreverent ("Lost in the Flood" on *Greetings*) to worshipful ("Jesus Was an Only Son" on *Devils & Dust*). Some of his earliest songs, such as "Sister Theresa" and "Resurrection," are bitterly anti-Catholic, full-throttle attacks on the Church as an institution. "If I Was the Priest," which he performed at an audition for record producer John Hammond before securing his first record deal and which finally appeared on an official release, *Letter to You*, in 2020, has been described as blasphemous. It might be set in a mythical American West, but the imagery has deep Catholic roots. Jesus himself is the local sheriff. The Virgin Mary runs a saloon at night but still manages to say Mass on Sundays while working as a prostitute on Mondays. Here Springsteen seems to be exorcising his personal demons, expressing anger at the treatment he received at his Catholic elementary school in Freehold.

Other songs in this vein—some still not officially released—allude to religious themes and address primal emotions. With titles like "Black Nights in Babylon" and "Calvin Jones & the 13th Apostle," they suggest a young man coping with ambivalent

feelings toward the Church. Subsequent songs continued the sacrilegious themes, and none more so than "Lost in the Flood" on *Greetings*. The imagery is striking as well as disturbing. Bald, pregnant nuns run through the halls of the Vatican, "pleadin' Immaculate Conception." And in "It's Hard to Be a Saint in the City," from the same album, the devil appears like Jesus as he walks through the streets of New York.

Springsteen constantly invokes the language of Catholicism. He has often referred to himself as a "runaway" Catholic. His work is steeped in Catholic iconography and imagery and in the very language of the Catholic Church. As he has said, "Once you're in you can't get out." Religious metaphor and imagery is a language, he maintains, that most people can understand, no matter what their religion. "It is a language that we have in common," he said on the *VH1 Storytellers* television series. "Everybody has that geography inside them—a spiritual geography of some sort . . ."

Moreover, Springsteen gives ordinary people spiritual, even perhaps sacred, qualities. Theresa, the protagonist in "I'll Work for Your Love," is a bartender. But she is also an angelic figure, a good and humble soul surrounded by disaster. The Catholic imagery here is striking: "Stations of the Cross," "crown of thorns," "my temple of bones," "the garden before the fall." In this doom-filled song (despite the energetic arrangement), almost apocalyptic in nature, Springsteen even alludes to the "pages of Revelation" while the "seven drops of blood" refer to Christ's Passion. But still Theresa continues to pour her glasses of beer as the world outside falls apart ("our city of peace has crumbled").

Among his most Catholic albums is *Tunnel of Love*, which is essentially a collection of musical short stories. Listening to it, you feel as if you are eavesdropping on private conversations or hearing the story of someone's life unfold. Journalist and author Eric Alterman has compared the songs on the album to the works of Raymond Carver. Springsteen, like Carver, writes about people trying to discover—and retain—their moral compass in a complicated, often amoral, world. But what is most striking about the

album is its profound use of Catholic imagery. As mentioned, the Springsteen songbook is full of Catholic symbolism: light and water, prayer and God, church bells and themes of redemption and grace. The Catholicism expressed here is of such a sacramental nature that the late priest-sociologist Andrew M. Greeley in the February 6, 1988, issue of *America*, the Catholic weekly, felt compelled to describe Springsteen as a Catholic "liturgist," a Catholic "minstrel"—lapsed Catholic or not. And in a piece of poetic hyperbole, Greeley even went so far as to the call the 1987 release of *Tunnel of Love* as perhaps "the more important Catholic event in this country than the visit of Pope John Paul II." Not to be outdone, in Michael Chabon's novel *The Mysteries of Pittsburgh* one of the characters calls *Born to Run* the most Catholic album ever. In an interview with *Rolling Stone*'s Kurt Loder, Springsteen himself has called it a "religiously based" record, "in a funny kind of way. Not like orthodox religion," he emphasized, "but it's about basic things, you know? That searchin', and faith, and the idea of hope."

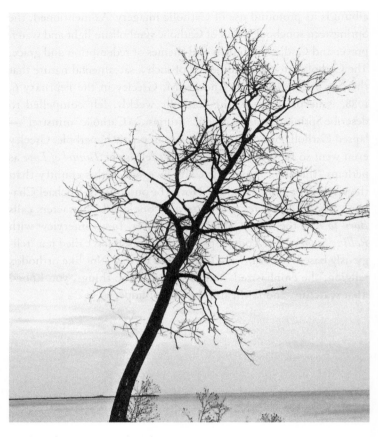

Bare Tree (Marquette, Michigan)

CHAPTER 4

The Good Book

Like Bob Dylan, one of his many musical mentors, Springsteen has turned to the Good Book itself for inspiration. References to the Bible are pervasive throughout the Springsteen canon, from Genesis and Exodus to Matthew and Ezekiel. He alludes to Daniel in "Lion's Den." Cain and Abel are mentioned by name in "Gave It a Name." The biblical phrase "wages of sin" from Romans happens to be the title of one of his bleakest and saddest songs, about the end of a relationship. The mark of Cain emerges in "What Love Can Do." The biblical imagery of forty days and forty nights appears in several songs, including "Soul Driver" and "Maria's Bed." The prophet Ezekiel, who sees the dead rise again in the valley of dry bones, is referenced in "Black Cowboys." On *Wrecking Ball*, the biblical story of Jonah and the whale is used as a contemporary metaphor. In "Swallowed Up (in the Belly of the Whale)," he condemns the corrupt practices of Wall Street executives and of rampant capitalism run wild ("Our faith that with God the righteous in this world prevail"). Which is not to say humor is completely absent. Occasionally his biblical references include a bit of levity too as when Eve tempts Adam with the apple in the hilarious "Pink Cadillac."

Sometimes biblical metaphors merge with pop culture. The rage that exists between father and son in "Adam Raised a Cain" (originally called "Daddy Raised a Cain") recalls the biblical story of Cain

and Abel, the two sons of Adam and Eve, in the Book of Genesis as much as the 1956 film adaptation of John Steinbeck's *East of Eden*. Steinbeck's title comes from chapter 4, verse 16, of Genesis: "And Cain went out from the presence of the Lord, and dwelt in the Land of Nod, on the east of Eden." Similarly, Springsteen refers to the murder of Cain by Abel by name in the lyrics "and east of Eden he was cast." Although the relationships differ—Springsteen's story is about antagonism between fathers and sons rather than fratricide—he too was striving for a primal mood and he even went so far as to return to the source (the Bible itself) for words and images that captured the flavor of the Old Testament that he wanted to evoke ("You inherit the sins, you inherit the flames").

Jesus himself is the topic of "Jesus Was an Only Son," perhaps Springsteen's most profoundly spiritual lyric. The song is simple yet devastating in its expression of the most fundamental of emotions: the love of a mother for her son and the finality of death. "She's just losing her boy," Springsteen offers. He approaches the Passion of Christ from a secular perspective in order to emphasize Jesus's humanity. But it is also written from the perspective of a parent—Springsteen acknowledged how profoundly moved he was by the birth of his first born—who realizes that no matter what we may do to protect our children, ultimately their fate and safety are beyond our control.

Springsteen reflects on the what-ifs of Jesus's life: What if he married? What if he had a family? In this most Catholic of songs, Springsteen reduces the story of Jesus and Mary to loyalty, commitment, and endurance—the unconditional love between a mother and her son. On the *VH1 Storytellers* television series, he told the audience of how he wanted to write a song about the relationship between parents and children, in this case between a mother and a son. He was thinking of Jesus as someone's "boy." He wanted to write about Jesus' human side—that a historic figure called Jesus actually walked the earth. The song concludes on a poetic note as Jesus tries to console his mother as he approaches the time of his

own death: "Mother, still your tears, for remember the soul of the universe willed a world and it appeared."

But no other biblical term is more associated with Springsteen, nor attached with more portentous significance, than the iconic Promised Land. The idea of the Promised Land dates back to America's beginnings.

In 1630, John Winthrop, an English Puritan and the first governor of Massachusetts, delivered his famous sermon, "A Model of Charity," on board the ship *Arabella*. "Charity" is considered the founding document of what would later become the United States and instilled within the country the American notion of the Promised Land. Winthrop and his fellow Puritans believed their journey to the New World was a "divine blessing"—that they were creating a new society, their "city on a hill." The biblical images Winthrop employed were later to be used as justification for everything from Manifest Destiny and the subsequent expansion of U.S. territory to the eradication of Indigenous peoples from the land and eventually, further on down the line, the basis for American exceptionalism.

Springsteen's Promised Land has many meanings. In "Johnny Bye-Bye" (his homage to Elvis Presley), "Racing in the Street," and "Galveston Bay," it evokes an idyllic Garden of Eden where the protagonists can find peace and refuge. In "Goin' Cali," a particular place—California—is the coveted Promised Land. Sometimes, though, it is laced with sarcasm. In *The Ghost of Tom Joad* the protagonist knows that the vaunted Promised Land is more legend than reality and will lead nowhere. On the other hand, in the song "The Promised Land" the concept represents the hopefulness and optimism of America itself, a contemporary version of the Exodus story, of how the children of Israel left slavery behind in Egypt led by the prophet Moses who guided them through the wilderness to Mount Sinai where God promised them the land of Canaan in return for their faithfulness. The singer believes in the possibility of *this* Promised Land even if he himself ("Sometimes I feel so weak I just want

to explode") has not quite arrived there yet. Ultimately, though, Springsteen's Promised Land represents the myth, and promise, of America itself. In his vision of the Promised Land, Springsteen tells and retells the foundation myth of America and its complicated narratives of sin and redemption, forgiveness and grace, slavery and freedom: creating a paradise lost in a fallen land.

The idea of the Fall has long been on Springsteen's mind. In 2004, when he inducted Jackson Browne into the Rock and Roll Hall of Fame, he commented on the Fall, on redemption, on the idea of divinity. If the Beach Boys offered California as a kind of paradise then Browne in "pop gospel" songs like "Rock Me on the Water" and "Before the Deluge," he said, "gave us Paradise Lost."

> Now I always thought that in our fall from Eden . . . our real earthly task was that an unbridgeable gap, or a black hole, was opened up in our ability to love one another. And so our job here on earth—and the way we regain our divinity, our sacredness, and our general good standing—is by reconstructing love and creating love out of the broken pieces that we've been given. That's all we have of human promise. That's the way we prove ourselves in the eyes of God and facilitate our own redemption.

Springsteen's more recent songs are also bathed in the mystery of faith, and doubt. As he has aged, he has become less sure of certainty. To him, doubt is not a sign of weakness but rather an acknowledgment of maturity. "Why would you not be humble in the face of that mystery?," he asked Phil Sutcliffe in the January 2006 issue of *Mojo* magazine. "Why would you assume that the answers can be handed down to you, A to Z, no room for doubt?"

He continues, "That's child-like, that desire for answers. Adult life is dealing with an enormous amount of questions that don't have answers. So I let the mystery settle into my music. I don't deny anything, I don't advocate anything. I just live with it. We live in a tragic world, but there's grace all around you. That's tangible. So you try to attend to the grace."

More than a dozen years earlier, in 1992, Springsteen discussed the dichotomy between wishful thinking and reality. "Even though some part inside of us yearns for a morally certain world, that world doesn't exist. That's not the real world. And at some point you've got to make that realization, make your choices, and do the best that you can."

As Springsteen has matured as an artist and as a human being, Catholic and indeed broader Christian iconography has deepened beyond sin, redemption, salvation, and the search for the Promised Land—the usual tropes of the Springsteen iconography. Springsteen's religious stance extends to the stage too. But whereas Springsteen the lyricist employs a mostly Catholic perspective, Springsteen the performer almost exclusively adopts the persona of a fire-and-brimstone revivalist-style Protestant preacher, as he eagerly—gleefully even—admits his sinful ways. Even Barack Obama saw the resemblance: "You might have been a preacher, Bruce," he told him in *Renegades*. "You might have missed your calling."

Unlike real-life preachers, though, Springsteen doesn't ask for forgiveness. Rather he invites the audience to join him as part of the larger human race: saints and sinners alike—but especially sinners—celebrating each other's flaws and failures. He employs the call-and-response technique, borrowing from the Black gospel, soul, and R&B traditions that he listened to growing up in New Jersey. Like his counterpart in "Thunder Road," he is no savior but just an ordinary man from the Jersey heartland trying to find his way and helping the audience find theirs. "Show a little faith," he has exhorted down through the years. "There's magic in the night."

His gloriously optimistic gospel song "Land of Hope and Dreams" is a case in point. Combining the secular and the spiritual, Springsteen celebrates Lincoln's "better angels of our nature," that of an America writ large. The song uses the heaven-bound train, the celestial railway, as its central metaphor. Specifically, Springsteen borrows from folk songs, freedom songs, and spirituals to create something wholly his own. The refrain may be a twist on the old

African American spiritual "This Train (Is Bound for Glory)," which in turn echoes the lyrics of several old gospel songs about the Promised Land. "Land of Hope and Dreams" also references the Impressions' 1965 "People Get Ready," written by Curtis Mayfield, which in turn was inspired by the 1963 March on Washington. And like its spiritual predecessor, "This Train," Mayfield's song also refuses to welcome sinners on board.

Springsteen's song recalls that Jesus's followers emerged from the common humanity. His advocates were fishermen, the reviled, the socially marginalized, outcasts and outsiders, prostitutes and sinners, and even at least one friend who would betray him. These are the same people whom Springsteen elevates in his song of communal belonging that emulates a Christlike friendship toward everyone.

Springsteen combines the elements of all these songs—but with a key difference, and it is a crucial one. On *his* train, in *his* metaphorical land of hope and dreams, *everyone* is welcome: saints and sinners, losers and winners, whores and gamblers, fools and kings. The song is about redemption *and* forgiveness. And like *his* version of America, it is inclusive and democratic and spiritual, a communal celebration of universal brotherhood.

In an email shared with me in 2023, American studies scholar Bill Savage referred to the notion of "I becoming We" in John Steinbeck's *The Grapes of Wrath* as the characters move from the individual to the collective. By that he means "when oppressed people are willing to sacrifice individual immediate well-being to make things better for everyone . . . in the long run." Essentially, a triumph of solidarity over individualism, the I-and-we dynamic is personified in the novel in the Christ figure of Preacher Casy and in the "one big soul" speech of Tom Joad. "A fella ain't no good alone," Tom says at one point.

Steinbeck dares to assert that regular people are worthy of representation in art even if the infrastructure is unable, or unwilling, to make room for everyone. "There ain't enough room for you an' me, for your kind an' my kind, for rich and poor together all in one

country, for thieves and honest men." On the other hand, in the expansive, if aspirational and romantic, vision of Springsteen's America, all are welcome, as he sings in "No Surrender," to live under "a wide open country."

Indeed, Springsteen includes his own version of Steinbeck's politics of charity in "The Ghost of Tom Joad." An analogy could also be made, I suggest, that over the length of his career Springsteen has moved from the individual "I" of himself to the "we" of the E Street Band and, by broad extension, the "we" of his audience.

Drive Thru Open (Port Huron, Michigan)

CHAPTER 5

The Populist Imperative

Jesus's teachings are so radical, they're just insanely generous and apocalyptic.

—Barbara Ehrenreich

From *Darkness on the Edge of Town* to *Wrecking Ball* to *Letter to You*, Springsteen's music is an artful example of the populist imperative; that is, his overall body of work champions a mindset that celebrates civil equality and social morality. As heir to both Woody Guthrie and John Steinbeck (among others), he follows in their tradition of social conscience, left-wing populism, and promotion of the common good. Moreover, several philosophies and doctrines form the foundation of Springsteen's vision of America.

The Springsteen ethos evolves from several key sources:

- his Catholic heritage, specifically Catholic social teaching
- the Social Gospel doctrine
- old-fashioned liberalism
- Roosevelt's New Deal populism

Generally speaking, Springsteen's brand of liberal politics seems to be rooted, whether consciously or not, in a combination of these movements, doctrines, and philosophies, as well as an ample dose

of the secular Golden Rule. Above all, he is concerned with fairness, integrity, justice, and common decency—all strong social justice issues.

Catholic social teaching (CST) is a doctrine developed by the Catholic Church that addresses poverty and economics and the role of the state. The foundation of the teaching rests on the age-old ideas of the importance of human dignity, the common good, charity, community, and social justice. It echoes too the prophetic books of the Old Testament and the teachings of Jesus Christ as they appear in the New Testament. An especially important part of CST is that everyone has a fundamental right to life and the necessities of life, including employment, health care, and education.

The origins of CST can be traced as far back as Augustine of Hippo's *City of God*, where the theologian and philosopher discusses the characteristics of what makes the common good. Aristotle and Thomas Aquinas, in turn, influenced Augustine. By the late nineteenth century, the concept of the common good appeared in the papal encyclical letter *Rerum Novarum*, a social justice doctrine issued by Pope Leo XIII in 1891 that criticized the concentration of wealth and power among the societal elite. In 1965, the Second Vatican Council went even further with its *Gaudium et Spes* ("Pastoral Constitution on the Church and the Modern World"), which asserted the fundamental dignity of every human being. Vatican II called on the clergy to focus on the poor by creating what is now known as the Catholic Campaign for Human Development, an antipoverty and social justice program (in 1985, the Church's Developing Communities Project hired a non-Catholic community organizer by the name of Barack Obama to liaison with the largely Protestant African Americans on the South Side of Chicago). The spirit of the program continued throughout the 1970s and 1980s and is perhaps best embodied in the progressivism of Cardinal Joseph Bernardin in Chicago, who famously called for a "consistent ethic of life" that wove life and social justice issues into a "seamless garment." Pope Francis brought the issue of social justice back

into the public square. In 2013, he released the eighty-four-page *Evangelii Gaudium* ("The Joy of the Gospel"), which roundly criticizes unbridled capitalism and contemporary "throw away culture." He asserts that the Catholic Church's primary mission and duty is to establish and maintain economic, political, and legal justice. In the encyclical, he issues a call for action that will transcend Adam Smith's "invisible hand" philosophy to combat the structural causes of inequality. Most significantly, he questions society's priorities, asking, for example, why it is that when an elderly homeless person dies of exposure it is not considered newsworthy "but it is news when the stock market loses two points." Some of his more adamant critics have called *Evangelii Gaudium* a radical document (conservative talk show host Rush Limbaugh, for one, dismissed the pope's views as Marxist), and yet Francis's comments not only reflect traditional CST but also echo, to these ears at least, the righteous anger heard on Springsteen's *Wrecking Ball* album, especially in "Easy Money," "Jack of All Trades," and "Death to My Hometown." Nearly a decade later, during his Christmas Eve homily at St. Peter's Basilica in December 2022, the pope spoke about the true meaning of Christmas and decried the principal victims of human greed: the weak and the vulnerable. "Jesus was born poor, lived poor and died poor; he did not so much talk about poverty as live it, to the very end, for our sake. . . . From birth to death, the carpenter's son embraced the roughness of the wood, the harshness of our existence."

The key principles of CST—human dignity, solidarity and the common good, charity, distributive justice, community, care for the poor and vulnerable, the inherent dignity of work—also form the heart and soul of Springsteen's ethos. Did Springsteen learn these teachings from the nuns at St. Rose of Lima in Freehold? Probably not although his Catholic worldview never left him. Actually, whether Springsteen is aware of these official church doctrines is beside the point. It is more likely that whatever he knows about the teachings he discovered from his own reading, the people he

met on the road, and his own personal experiences with family and friends.

The Catholic faithful are obliged to promote social justice and assist the poor, the sick, the elderly, and victims of injustice and oppression. According to CST, how moral a society is can be determined by how it treats its most vulnerable members. Another important tenet of CST—and hugely important in the Springsteen canon—is the inherent dignity of work. It is the responsibility of employers to create jobs that uphold the dignity of all workers. Workers, in turn, have a right to employment, to earn a living wage, to form trade unions, and to labor under safe working conditions.

In short, Springsteen's overall body of work promotes a brand of social justice that is contained within both the Social Gospel and CST doctrine. In the lyrics and even in his public persona, Springsteen practices a specific form of leadership that scholars call *servant leadership*.

The Protestant Social Gospel follows similar dictates. An intellectual movement that peaked during the early years of the twentieth century that emphasized the importance of Christianity to help abolish social inequality, the movement and its followers applied broad Christian ethics to social problems, especially issues of social justice, such as economic inequality, poverty, crime, and discrimination. Its founder, Walter Rauschenbusch, promoted a form of Christian socialism, what in Europe might be called social liberalism, that fought against "selfish" capitalism, which at its crudest form can be defined as a "hurrah for me and to hell with the rest of you" attitude. I further contend that Springsteen's CST-steeped philosophy is the antithesis of the so-called prosperity gospel of self-help Protestant televangelists who believe pious behavior will lead to an increase of material wealth.

Another example of Catholic-based social justice is the Catholic Worker Movement, founded in 1933 by the journalist and social activist Dorothy Day, an organization that remains active today. Catholic Workers lead lives of poverty and service to the poor and, in particular, fought for the rights of the oppressed. The essence of

the movement can be expressed by asking a very Springsteen-esque question: "If Jesus were alive today, who would his disciples be?"

The apotheosis of Springsteen's Catholic faith is on *The Rising*, his musical response to the September 11 attacks, a raw, elemental album where he pursues the twin themes of redemption and salvation. "Into the Fire," about a firefighter facing certain death as he does his job, turns tragedy into prayer ("May your strength give us strength"). The poignant "You're Missing" becomes a secular hymn of loss and unbearable yearning. And the majestic title cut begins with images of firefighters climbing up flights of stairs through smoke and darkness as they confront frightening reflections of "faces gone black." But even as the rescue worker of the story is surrounded by death, the chorus proclaims an affirmation of life. It concludes with a vision of the Virgin Mary in the garden of the risen Christ. The sky that had once been black and filled with sorrow is now full of mercy and "blessed life," while the gospel strains of the music lift up the listener ("come on up for the rising"), evoking a sense of hope and the possibility of resurrection ("dream of life"), even when surrounded by painful remembrance. For here and elsewhere Springsteen bears witness to what Catholics call the communion of saints, suggesting an almost palpable community that exists between the living and the dead, or, in the words of one of his songs, "the ties that bind."

But something else is going on here. Jesuit priest and scholar Father Richard Blake calls it "afterimage," which he defines as an image "that remains after a stimulus ceases or is removed." He uses the concept to refer generally to the Catholic imagination, but it can be applied also to Springsteen's music. No one actually chooses a Catholic imagination. It just exists, as a product of one's upbringing. It is part of Springsteen's being, his fabric, whether he is aware of it or not. It is subliminal, unconscious. Among the major characteristics of the Catholic imagination—and I would suggest of Springsteen's imagination too—is the notion of sacramentality. Springsteen, I would argue, sees the presence of God in all things and in all people, whether saint or sinner.

The communities most deeply affected by the September 11 attacks were working-class neighborhoods; many of the victims were police officers and firefighters. Monmouth County, deep in the heart of Springsteen country, lost nearly 150 people when the Twin Towers collapsed—more than any other county in New Jersey. And a good portion of the victims were Springsteen fans; in fact, their families played Springsteen songs at funeral services. In his memoir, *Born to Run*, he notes that "[f]or weeks, the long black limousines pulled up to churches and candlelit vigils were held in the neighborhood park. In Rumson, a town full of Wall Street commuters, almost everyone knew somebody who lost somebody."

To flesh out the details of the story, to capture the essence of the narrative that he wanted to share, Springsteen interviewed survivors of the emergency workers who perished that day, not to exploit their grief but to share their stories for posterity.

Springsteen turns a song about destruction into a triumphant tale of renewal; he repeats the mantra "dream of life" over and over. There is hope amid the loss, life even when surrounded by death. Springsteen has called *The Rising* his version of the Stations of the Cross, with the firefighter playing the role of the sacrificial Jesus.

Another song from *The Rising*, the stately "My City of Ruins," about Springsteen's adopted hometown of Asbury Park, is deeply spiritual. In ways both profound and superficial, the ruins of Asbury reflected the psychological state of the nation. As a gorgeous piece of white gospel, "My City of Ruins" has much in common with Curtis Mayfield's civil rights anthem "People Get Ready," both in its stately pace and melody as well as in its elegant arrangement. It also contains a great lyric, evoking the despair of a place where there is little hope. The rain is falling down, the church doors are left open, but the congregation is gone while young men stand on street corners "like scattered leaves," surrounded by boarded-up windows and empty streets.

The chorus on "My City of Ruins" serves as a prayer ("May your strength give us strength / May your hope give us hope . . ."), and,

accompanied by the warmth of Danny Federici's organ, Springsteen sings with an increasing sense of urgency, praying for the strength to continue, for the faith to believe again, for the love to sustain him. Ultimately, "My City of Ruins" is about learning to begin all over again—both in a physical place and in a relationship—and of the importance of creating community even among the "ruins."

Here, Springsteen plays the role of Everyman, the nation's town crier. A city is destroyed by abject poverty and benign neglect, but Springsteen not only describes the situation but does much more than this—he exhorts the crowd to actually do something about it. With a powerful refrain of "Rise up!" delivered with all the fervor of a latter-day preacher (albeit a secular rock and roll one), Springsteen demands action. The notion of social justice—I am my brother's keeper—is a fundamental part of Catholicism, and this aspect of his cradle faith would surely have appealed to him as a lapsed Catholic with a strong social conscience. But he is also realistic. Springsteen doesn't promise to take away the pain—no one can do that—but he does remind us that we are not alone in our suffering.

Particularism is a political theory that each political group owes its allegiance only to itself. On the other hand, universalism proclaims that it is not enough to care just for your own. There is also a greater responsibility to fix when it is broken as part of a broader struggle for social justice. Are we accountable only to ourselves? Are we not our brother's keeper? Pope Francis believes in this type of universalism. It can also be found in Judaism under the Hebrew idiom of *tikkun olam*, or "repair of the world"—almost a biblical commandment to do better. I would suggest that Springsteen, the artist, also follows this dictum in his work. Instead of repairing the world through good deeds, he does it through good songs. Especially in some of his most recent work, the singer has defined social inequality in strikingly moral terms, as a moral obligation.

Perhaps the most Catholic aspect of Springsteen's persona is his need for communion, his confessed love of community, trying to

find the audience that reflected what the imagined community that was in his head looked like and that shared similar ideals that were reflected in his songs. Like the characters in a Martin Scorsese movie, Springsteen's characters also want redemption. But the redemption that they so desperately seek cannot be accomplished alone—as it can for, say, their Protestant brothers and sisters—but rather only through cooperation with others, as members of a broader community. Most importantly, Springsteen's notion of community is reflected in the importance that he attaches in his songs to Catholic ritual, whether it is something as simple as combing his hair "just right" before going out into the cool of the evening ("Growin' Up") or lighting a candle so that his love can make it safely home ("Mary's Place"). Indeed, Catholic ritual is woven into the very fabric of his songwriting.

Springsteen's critics sometimes dismiss him as a liberal and leave it at that, the implication being that someone of his background (a self-educated community college dropout) should keep his opinions to himself and stay out of politics altogether. But it is worth exploring the deep roots of his brand of liberalism.

Seventeenth-century English philosopher John Locke is considered the father of modern liberalism. But liberalism also has much in common with the social contract ideals espoused not only by Locke but also by Thomas Hobbes and Immanuel Kant. Kant's moral philosophy condemned the gulf in society between theory (what we as a society should do) and practice (what we actually do). Of course, there are many other strands of liberalism, a discussion of which is beyond the scope of this book, but they range from the classical variety of Adam Smith and Jeremy Bentham to the new liberalism of John Stuart Mill, the social liberalism of J. A. Hobson, the Keynesian economics of John Maynard Keynes, and the neoliberalism of Friedrich Hayek and Milton Friedman.

In the United States, liberalism is often associated with the policies of Franklin D. Roosevelt and later the Great Society programs

of Lyndon Johnson. Indeed, many of liberalism's core ideas can be found in the democratic capitalism of Roosevelt's New Deal doctrine. On January 11, 1944, Roosevelt proposed a list of rights, which he called the Second Bill of Rights (also known as his economic Bill of Rights), in his State of the Union Address. From a twenty-first-century perspective, his goals are breathtaking in their sweep and magnanimity. In his view, the original Bill of Rights was not enough to guarantee the individual right to pursue happiness. His solution was to come up with an economic bill of rights that would guarantee, among other things,

- employment with a living wage;
- freedom from unfair competition;
- decent housing;
- universal health care;
- quality education.

As a political doctrine, liberalism had fallen on hard times during the conservative presidency of George H. W. Bush and the co-called compassionate conservatism of George W. Bush (notwithstanding Bill Clinton's in-between terms and his so-called triangulation doctrine), but the election—and reelection—of Barack Obama led to a liberal revival of sorts that centered on closing the gap between rich and poor. The 2020 election of Joe Biden, the ultimate career politician, ushered in a different kind of liberalism, one based on pragmatism, collegiality, and an attempt, if not always successful, at bipartisanship.

Whether called the populist imperative (Paul Krugman's preferred term, which I also prefer) or new left populism (Joe Klein), it seems clear that there is an ongoing interest by a considerable portion of the citizenry for the government to address income inequality and bulk up the tattered social safety net, that government can and should play a major role in providing necessary services when the private sector cannot or fails to do so, especially in post-pandemic

America. This is certainly Springsteen's brand of liberalism—my interpretation of it at least. Indeed, the values often associated with middle-class aspirations—opportunity, responsibility, community—are precisely the values that form the foundation of Springsteen's canon.

All of liberalism's "guarantees" find expression in one form or another in Springsteen's larger body of work. His characters have experienced a loss of faith, in themselves and in their country and government. Looking over his oeuvre, it is apparent to this observer that Springsteen has done future researchers of the American social fabric of the twentieth and twenty-first centuries a favor, for by carefully following his career one can come to better understand late twentieth- and early twenty-first-century America. He does this not by presenting solutions to intractable problems but instead by offering portraits—precisely rendered—of people, fictional though they may be, who are emblematic of a very real group of Americans, namely, members of the working class and middle classes. Moreover, his entire oeuvre can be looked at as being part of a deeper American cultural canon that includes everyone from Stephen Foster to Mark Twain, Woody Guthrie to John Steinbeck coupled with a very strong dose of CST doctrine and that even touches on—whether knowingly or not—aspects of the moral and political social justice beliefs of American philosopher John Rawls, whose *A Theory of Justice*, published in 1971, advocated equal basic rights and equality of opportunity, promoting the interests of the least advantaged members of society.

In 1996, Elaine Steinbeck, John's widow, presented Springsteen with the John Steinbeck Award. (The award is given to an individual or group that has contributed to society in the "spirit" of John Steinbeck.)[1] On the night of October 26, 1996, Springsteen performed *The Ghost of Tom Joad* at San Jose State to benefit the Center for Steinbeck Studies, ending the concert by reading a passage from *The Grapes of Wrath*. According to the John Steinbeck Award website, at the reception afterward, Elaine Steinbeck said,

"If my husband were alive, he would have wanted every word Bruce sang tonight included in as prologue of *The Grapes of Wrath*."

Years later, during the height of the COVID-19 epidemic, Springsteen accepted the Woody Guthrie Prize in a virtual ceremony. During his acceptance speech he told Guthrie's granddaughter Nora not only that Guthrie's music served as an inspiration for him during the writing of *Darkness on the Edge of Town* but also that without Guthrie he might not have been able to tell the stories he told on the album.

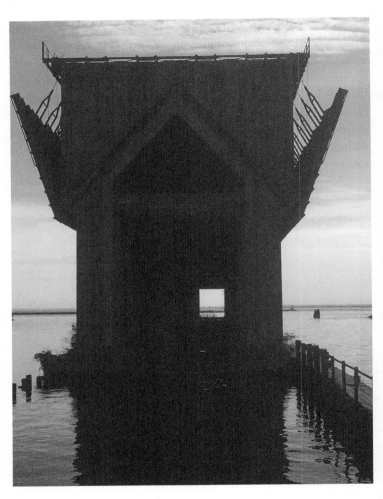

Ore Dock (Marquette, Michigan)

CHAPTER 6

Hope and Dreams

Over the years, Springsteen has tackled social justice issues head-on in the lyrics of his songs. Separated by more than a dozen years, *Nebraska*, in 1982, and *The Ghost of Tom Joad*, in 1995, may both be sparse collections of songs about diminished hopes and diminished expectations in contemporary America, but so too are *Magic*, *Wrecking Ball*, and *High Hopes*, all released within a decade of each other. Of course angry white men are nothing new in the Springsteen songbook. From "Nebraska" and "Seeds" to "Youngstown" and "Jack of All Trades," Springsteen has dared recognize the marginalized white, Brown, Black, and poor of the country more than almost any other songwriter. Where some critics might have seen repetition, Springsteen saw continuity. He was telling different versions of the same songs and of the same type of people because that was what needed to be done: nothing had really changed.

Contemporary concerns feature prominently in Springsteen's songs. He sang about the AIDS epidemic in "Streets of Philadelphia" (it earned him a 1994 Academy Award for Best Song); "Souls of the Departed" conflates dying soldiers during the first Gulf War with a child's death in gang-ridden Compton, California; the Iraq War appears in "Devils & Dust" and "Last to Die"; most of *Magic*, his 2007 release, was a response to George W. Bush's policies, particularly rendition and waterboarding; and most recently, he

tackled the Great Recession in "Easy Money," "Death to My Hometown," and "Shackled and Drawn," the latter a working-class howl of fury. Springsteen has called *Magic* his "state-of-the-nation dissent over the Iraq War and the Bush years." Among his most polarizing, and misunderstood, songs is "American Skin (41 Shots)," a searing but measured account of racial profiling related to the fatal police shooting of an unarmed African immigrant, Amadou Diallo, in New York City in 1999, that appeared on the *Live in New York City* album. When the song was criticized as an antipolice diatribe, members of a New York police benevolent association called for a boycott of Springsteen's New York City concerts during the E Street Band's 1999–2000 reunion tour. The song resurfaced in April 2012 when Springsteen performed it on the *Wrecking Ball* tour in response to the shooting of Florida teenager Trayvon Martin. An updated rendition appeared on his 2014 album, *High Hopes*.

Nebraska and *Wrecking Ball* form bookends to the ongoing economic crises facing America over the past thirty or so years. The lyrics reflect the stagnation of middle-class wages and the widening inequality between the haves and the have-nots. What they also acutely address, and with great sensitivity, is the national unraveling of the social fabric. From "My Hometown" on *Born in the USA* to "Death to My Hometown" on *Wrecking Ball*, Springsteen offers empathic portraits of people and entire communities in collapse.

Many, if not most, of Springsteen's most indelible characters are outliers living, barely surviving, on the edge of society. The protagonists that appear on his most political albums are assorted groups of misfits and outsiders: Johnny in "Johnny 99," the Charles Starkweather character in "Nebraska," the ex-con in "Straight Time," the frustrated Vietnam veteran with nowhere to turn in "Born in the USA," the angry laborer in "Jack of All Trades," and the hatred-filled man eager to exact revenge on society in "Easy Money" are well beyond the pale.

Many of these characters evoke the fictional character of Ethan Edwards, portrayed by Hollywood's archetypal hero John Wayne,

in John Ford's iconic 1956 *The Searchers*—a film that had a profound impact on Springsteen. I'll say more about this Western classic later, but I do want to note that when he was writing the songs that make up *Nebraska*, Springsteen was watching a steady diet of classic Hollywood movies, especially film noir (Fritz Lang's *You Only Live Once*, Nicholas Ray's *They Live by Night*, Arthur Ripley's *Thunder Road*). In songs like "Stolen Car" from *The River*, he captures the essence of noir. "I ride by night and I travel in fear / That in this darkness I will disappear."

Another film that made an impact on Springsteen at the time was Charles Laughton's *The Night of the Hunter*. The hymn-singing preacher Harry Powell, played by droopy-eyed Robert Mitchum (the character is partial to the gospel hymn "Leaning on the Everlasting Arms" as he drives his car through Depression-era America), marries widows for their money and then quickly disposes of them.[1] Similar to Springsteen's character in "Cautious Man" on *Tunnel of Love*, the preacher has the word "hate" tattooed across his left knuckles and "love" on his right knuckles.

One can almost trace the arc of Springsteen's political growth by looking at the political events, concerts, and rallies he has participated in over the years: the No Nukes concerts in 1979; the Vietnam Veterans of America Foundation benefit in 1981; his appearance in 1985 on the "We Are the World" benefit single for African famine relief; the Human Rights Now! tour in 1988; the benefit concerts in late 1990 for the Christic Institute, a left-wing think tank; and the presidential campaign rallies for John Kerry in 2004 and Barack Obama in 2008 and 2012.

The No Nukes concerts were a series of fundraisers sponsored by the Musicians United for Safe Energy (MUSE) and organized by Jackson Browne, Graham Nash, Bonnie Raitt, and John Hall. In March 1979, the worst nuclear accident in U.S. history took place at Three Mile Island, when a partial nuclear meltdown occurred in Dauphin County, Pennsylvania, ten miles from the state capital of Harrisburg. Anti-nuclear demonstrations were held throughout the country in protest, the largest in New York in September of that

year. The New York rally was staged in conjunction with the final two shows of No Nukes concerts and held at Madison Square Garden.

The songs that Springsteen and the E Street Band performed were not political in nature—consisting of the so-called Detroit Medley of "Devil with a Blue Dress On," "Good Golly Miss Molly," "Jenny Takes a Ride!," and "C.C. Rider"—but the very fact that Springsteen agreed to attend is significant in itself. Springsteen had not been on the road with his band since the *Darkness* tour ended nine months earlier. And yet the Three Mile Island accident had inspired one of his most powerful protest songs, "Roulette"— his first topical song. In the song, Springsteen takes on the persona of a firefighter as he and his wife and children are forced to leave their home after a nuclear accident occurs but have nowhere to go; they feel abandoned and betrayed by their employers and the government.

During the 140-stop *River* tour, which kicked off in Ann Arbor, Michigan, in October 1980, Springsteen vocalized his reservations about the direction that he saw the country heading. The election of conservative Republican Ronald Reagan as president only reinforced Springsteen's fears of an American society where rampant individualism under the guise of self-reliance surpassed the concept of community. By this time, Springsteen had read Joe Klein's seminal biography on Woody Guthrie and began singing his own rendition of Guthrie's "This Land Is Your Land." He supplemented his reading with other classics of American literary culture and social history, including John Steinbeck's *Grapes of Wrath*, Henry Steele Commager and Allan Nevins's *Pocket History of the United States*, and Howard Zinn's *A People's History of the United States*. In addition, he began adding to the *River* set list such Vietnam War–era songs as Creedence Clearwater Revival's "Who'll Stop the Rain" and "Run through the Jungle."

As it turns out, in 2014, Springsteen admitted to the *New York Times* that he didn't begin reading seriously until he was twenty-eight or twenty-nine years old. "Then it was Flannery O'Connor,

James M. Cain, John Cheever, Sherwood Anderson, and Jim Thompson.... These authors... brought out a sense of geography and the dark strain in my writing, broadened my horizons about what might be accomplished with a pop song and are still the cornerstone literally for what I try to accomplish today." Lost in the bleak imagery and moral ambiguity of O'Connor's short stories, Springsteen felt "the unknowability of God, the intangible mysteries of life that confounded her characters," he told the *Times*, "and which I find by my side every day. They contained the dark Gothicness of my childhood and yet made me feel fortunate to sit at the center of this swirling black puzzle, stars reeling overhead, the earth barely beneath us." O'Connor was so fundamental to his storytelling that he even borrowed her titles, or a variation of them, for his own songs, such as "A Good Man Is Hard to Find (Pittsburgh)" or "The River."

On *Nebraska*, he wrote songs about shame and loss—often written from a child's perspective—that was rooted in his 1950s-era New Jersey childhood. As he told Warren Zanes, it was his grandparents' house in Freehold that formed the foundation of the stories in *Nebraska*. "It had a kerosene stove to heat the whole place," he said, "a coal stove to cook on in the kitchen, very old-school Irish." In *Nebraska,* perhaps more than any other of his works, Springsteen offers a kind of radical empathy as well as a refusal to pass judgment. We may not quite see ourselves in the criminal activity of the protagonist in "Johnny 99" or identify with the Charles Starkweather character in the title song but we can at least acknowledge their humanity. Like O'Connor, Springsteen sees the hollowness in the human character and, by writing about it, brings it to the surface.

While on a road trip to the American Southwest, at a drugstore in Arizona Springsteen had found a paperback edition of *Born on the Fourth of July*, the best-selling memoir by antiwar activist Ron Kovic (later to be a critically acclaimed film starring Tom Cruise and directed by Oliver Stone). By serendipity, he met Kovic a few days later in Los Angeles and expressed his admiration for the book.

Kovic, in turn, put him in touch with Bobby Muller, another wounded Vietnam War veteran who had established a national organization, the Vietnam Veterans of America (VVA). Learning that the organization was low on funds, Springsteen and his manager Jon Landau and Muller himself arranged a benefit concert in 1981 for the VVA. "Without Bruce Springsteen, there would be no Vietnam veterans movement," Muller later said. Toward the end of the *Born in the USA* tour, Springsteen offered a scathing rendition of another Vietnam War–era song—and a Motown song to boot—"War" by Edwin Starr. At the Los Angeles Coliseum in 1985, he told the crowd, "Blind faith in your leaders, or in anything, will get you killed." Springsteen himself was able to avoid the draft when he received a 4-F deferment due to a brain concussion he suffered as a result of a horrific motorcycle accident when he hit his head on the pavement and knocked himself out. He was not wearing a helmet at the time.

His involvement in the Human Rights Now! tour in 1988 revealed yet a deeper commitment to the political process. Human Rights Now! consisted of twenty benefit concerts on behalf of Amnesty International that took place over a six-week span in 1988. The tour traveled to locations that Western artists at the time rarely visited, including India, Brazil, Argentina, and the African nations of Zimbabwe and the Ivory Coast. The purpose of the tour was to celebrate the fortieth anniversary of the Universal Declaration of Human Rights and to increase awareness of its existence and of Amnesty International generally.[2]

In addition to Springsteen and the E Street Band, the shows featured Sting, Peter Gabriel, Tracy Chapman, and Youssou N'Dour as well as guest artists in the countries where the concerts were held. It was more than just a series of concerts though. At each site, the musicians and Amnesty leaders held press conferences to discuss human rights. What's more, concert attendees were given copies of the declaration in their own languages.

Springsteen and the E Street Band performed an eclectic selection of songs culled from *Born to Run*, *Darkness on the Edge of Town*,

The River, *Born in the USA*, and *Tunnel of Love*. But they also featured several songs with strong social justice themes, including Bob Dylan's surrealistic tribute to all "hung up people" everywhere, "Chimes of Freedom"; a duet with Joan Baez of Dylan's 1960s classic "Blowin' in the Wind"; Woody Guthrie's "I Ain't Got No Home"; Starr's "War"; and an a cappella performance with his fellow musicians of Bob Marley's "Get Up, Stand Up."

> *It's been a long walk from the government that's supposed to represent all the people to where we [are now] . . . there's a lot of stuff being taken away from a lot of people that shouldn't have it taken away from them.*
>
> —Bruce Springsteen, 1984

It has been only fairly recently that Springsteen has openly offered his support of presidential candidates and made his political beliefs clear rather than merely implied. As recently as 1992, he flatly stated that he would not endorse any politician. Rock and roll was, he felt, transformative in and of itself. Rock and roll essentially functioned as freedom music—his freedom songs anyway. He didn't need to contribute to the public square. On the other hand, for many years he encouraged concertgoers at his shows to contribute to their local food bank—he still does—but that was the extent of his political activity.

But slowly his attitude began to change. Under the Reagan and later both Bush administrations, especially that of George W. Bush, Springsteen saw the United States drifting further and further away from what he considered its democratic values, that is, from its historic sense of economic and social justice. He began to voice his concerns as both an artist and a citizen. Not everyone was pleased. A considerable portion of his fan base undoubtedly felt that politics and music should remain at arm's length. But he persevered.

In 1996 he encouraged Californians to vote against Proposition 209, a piece of legislation that would have reduced funding for affirmative action programs in the state. Before a crowd of two

thousand in downtown Los Angeles, Springsteen participated in what Nicholas Dawidoff evocatively called "an old time liberal political rally." Among the speakers that day were then state senator and longtime peace activist Tom Hayden and Dolores Huerta, cofounder of the United Farm Workers. Also present was the Reverend Jesse Jackson, who, playing up Springsteen's all-American image, introduced the singer by the rather hyperbolic moniker of "Mr. America." Despite a life spent on the stage, this was still new territory for Springsteen ("he did appear a bit jittery," noted Dawidoff). Even so, Springsteen gave a short talk in which he reprimanded cynical, race-baiting politicians and then launched into a rousing rendition of "The Promised Land" followed by "No Surrender" as the encore. Afterward, reported Dawidoff, somebody in the crowd came up to Springsteen and asked, "So how does it feel to be a protest singer?"

On August 5, 2004, the *New York Times* published Springsteen's op-ed piece, which bore the title "Chords for Change." In it he expressed his philosophy—and his vision of America—and gave the reasons for his support of the presidential campaign of John Kerry and John Edwards. "I've tried to write songs that speak to our pride and criticized our failures," he begins. He lists the ideals that he believes in and writes about in his songs, namely, economic justice, civil rights, a humane foreign policy, freedom, "and a decent life for all of our citizens," essentially, the core foundation of the Catholic social teaching doctrine. He used the newspaper as a platform to announce that he would be touring, along with other musicians, as part of a group called Vote for Change.

The Vote for Change tour was organized by MoveOn.org, the nonprofit liberal public policy advocacy group, and in addition to Springsteen featured R.E.M., John Legend, John Mellencamp, the Dixie Chicks (now called the Chicks), and Pearl Jam, among other musicians. Springsteen sang at campaign stops for Kerry, accompanied only by his acoustic guitar. The songs he chose were telling: "The Promised Land" and "No Surrender." "The future is now," he told the crowd, "and it's time to let your passions loose. The country

we carry in our hearts is waiting." Four years later, he endorsed presidential candidate Barack Obama, and during one of the campaign stops just prior to the general election, he debuted "Working on a Dream," from his forthcoming album of the same name, an optimistic work that some critics believe was inspired by the arrival of Obama onto the political scene (although most of the songs were in fact written before Obama announced his presidential ambitions). Either way, Springsteen explained to his fans the reason for his decision and posted it on his website. Obama, wrote Springsteen, "has the depth, the reflectiveness, and the resilience to be our next President. He speaks to the America I've envisioned in my music for the past 35 years, a generous nation with a citizenry willing to tackle nuanced and complex problems, a country that's interested in its collective destiny and in the potential of its gathered spirit."

Springsteen also performed at the We Are One concert two days before Obama's first inauguration. He sang "The Rising" on the steps of the Lincoln Memorial with a gospel choir and then joined Pete Seeger for a full rendition of "This Land Is Your Land," including Guthrie's so-called radical verses, which condemned the excesses of capitalism.

In a 2013 op-ed piece that appeared in the *New York Times*, Amy D. Clark, an associate professor of English and coeditor of *Talking Appalachian: Voice, Identity and Community*, lamented the closing of the corner drugstore in her hometown of Big Stone Gap, Virginia, after it was sold to a franchise. The café that was located in the drugstore was for many years the hub of the local community, "an extension of the family kitchen." The loss of a store may seem like a small thing, but, as Clark notes, memories and ties are not forged in sterile superstores. "As the town inches toward homogenization, it loses a little more of its history, language, and architecture."

The Mutual Drug Cafeteria, as it was called, was located "steps away" from the massive Victorian homes that the nineteenth-century coal barons built. They still stand, up on a hill, but more as muted sentinels of a bygone era; they were in fact the nineteenth-century equivalent of contemporary gated communities. Their

existence recalls Springsteen's own memories of growing up in Freehold. In "Mansion on the Hill" he remembers the house "risin' above the factories and the fields" with equal part reverence, awe, and resentment. Steel gates surround the mansion. At night the singer and his father ride through the silent streets of the town, park on a back road, and look up at it, feeling like outsiders in their own hometown.

Conditions across the United States have only worsened since then. In an earlier America—and not that terribly long ago—a working-class family could rise to a higher social level because there were plenty of jobs, surrounded by family, friends, and neighbors—a community—to cushion the hard times. When the manufacturing foundation of many of these towns disappeared, such as Springsteen's own hometown, modest prosperity all but vanished. What were left in its wake were drugs and crime, culminating in the opioid crisis as well as distrust and isolation. But even as the working class was struggling to survive, wealthy professionals built their McMansions within their gated communities and the gap between the affluent and the poor or near-poor turned into a chasm.

Gun violence and especially the frequency of mass shootings are other aspects of societal breakdown. In 2022, more than six hundred mass shootings occurred in the United States, according to the Gun Violence Archives, a nonprofit research organization. Increasing mortality rates among predominantly white middle-class men caused by suicide, drug overdoses, and alcohol abuse all fall under this category. Economists Anne Case and Angus Deaton call these "deaths of despair." Sociologists Jillian Peterson and James Densley call mass shootings a form of suicide and a symptom of America's deep societal problems. Furthermore, they suggest that mass shootings are a way to seize power or gain attention and a small measure of fame—albeit short-lived. "These are public spectacles of violence intended as final acts," they note. Springsteen's lyrics are full of characters who often turn to these often fatal acts of desperation.[3]

The contrast with the egalitarian ethos that Springsteen writes about and the present reality of foreclosures and chronic

unemployment represents the collapse of the American Dream. Robert D. Putnam refers to the "radically shriveled sense of 'we.'" It is this lack of community, this lack of responsibility, this lack of caring for each other—Springsteen's we-take-care-of-our-own ethos—that is perhaps the biggest tragedy of all.

The theme that remains a constant throughout much of Springsteen's work is something that listeners of country music know well: the familiar premise of the haves versus the have-nots. Think of Steve Earle who once sang, "I was born in the land of plenty / now there ain't enough" ("Good Ol' Boy (Gettin' Tough)"). Others in the country and Americana field have addressed poverty (Haggard's "Hungry Eyes") and the political divide (James McMurtry's "We Can't Make It Here"). In "The Eyes of Portland," which appears on his *Orpheus Descending* album, John Mellencamp echoes Earle with the line, "in this land of plenty, where nothing gets done" but here is referring to the intractable problem of gun violence and the political lack of will to do anything about it.

There is an ongoing connection from song to song, album to album, from *Nebraska* to *The Ghost of Tom Joad*, *Devils & Dust*, *Magic*, *Wrecking Ball*, and *High Hopes*. It is this continuity of theme and the historical resonance in the music, in the way that Springsteen turns to his musical ancestors for inspiration whether Woody Guthrie or Hank Williams or Elvis Presley, Motown or soul, girl groups or R&B, that makes him a great political artist, whether he is considered a rock artist or, for that matter, a country artist. "I work to be an ancestor," he admitted in his memoir.

After country singer George Jones died in 2013, writer and critic Robert Cantwell wrote that his many fans heard the heartache in his voice and the "endurance of the white Southern underclass." Much the same can be said of the "country" songs of Bruce Springsteen. Springsteen too sings of the suffering, the desolation, the heartache but also the joy and fortitude of the white underclass, both north and south of the Mason-Dixon Line. The difference is that he just happens to do it (usually) without the Appalachian twang.

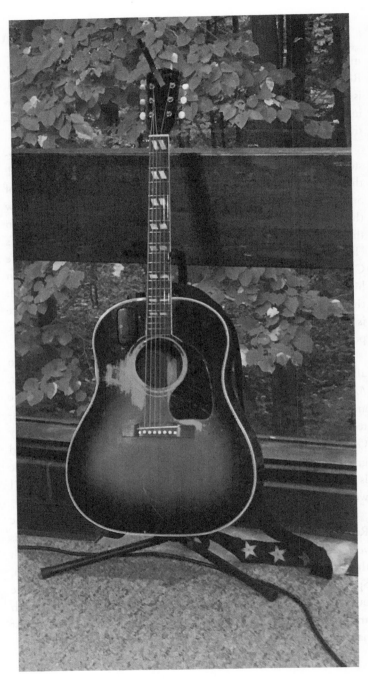

Mary's Guitar (Ann Arbor, Michigan)

CHAPTER 7

Left Behind

Absent public virtue, a republic can fail.

—David French

We had driven past it countless times on our way from Chicago to Pittsburgh, clearly visible off the Ohio Turnpike. It was a name that was easy to remember, hard to forget. It was almost biblical.

Lordstown.

Lordstown, home of a General Motors plant and where the Chevy Cruze (the car that Oprah Winfrey famously gave away on her show) was built. But now the once-packed parking lot lies empty. On March 6, 2019, General Motors permanently closed the Lordstown plant. It was a shock to the community even though it was a long time coming.

For as long as anyone could remember, steel mills and the thousands upon thousands of high-paying union jobs that went along with them had stretched for miles along the Mahoning River. Indeed, for a good part of the twentieth century, Youngstown, Ohio, was a great success story and the model of the American Dream. Thanks to the steel mills, the city's median income and home ownership rate were among the highest in the nation, for a time. By September 1977, though, Youngtown Steel and Tube announced the shuttering of its Campbell Works mill. "Within five years," wrote Derek Thompson

in the *Atlantic*, "the city lost 50,000 jobs and $1.3 billion in manufacturing wages. The effect was so severe that a term was coined to describe the fallout: *regional depression*." Since then Youngstown—and other towns and cities like it, especially in the Rust Belt states—has become a metaphor for the decline of labor overall. When jobs disappear, the cultural cohesion of a place is destroyed. The jobs offered security and a sense of community: now they were gone and it was just plain hard to get by. But it's not just Youngstown. In post-pandemic America, four out of ten Americans don't have enough money in the bank to pay unexpected expenditures as low as $400.

In 2016, the Republican presidential candidate, a former reality television star, became the unlikely symbol of hope for the working class and the struggling middle class, fanning the flames of white grievance and suggesting that working-class whites were the victims of politics of the left. (Some pundits have even referred to the times we live in as the Age of Grievance.) These people, these voters, soon became known as the Left Behind. They had the most to gain and the most to lose. A few years later, in 2023, journalist and op-ed columnist for the *New York Times* Nicholas Kristof offered, ". . . [W]e must make capitalism and democracy work better for those left behind—or people turn to charlatans."

In *Evicted*, his wrenching account of poverty in the United States, sociologist Matthew Desmond notes that every year people in the United States are evicted from their homes "not by the tens of thousands or even the hundreds of thousands but by the millions." Being forcibly removed from one's home must be among the most shameful and traumatic of experiences. Desmond calls it unnecessary and entirely preventable. "A different kind of society is possible," he offers in his Springsteen-esque conclusion, "and powerful solutions are within our collective reach."

But here's the rub. The solution rests on the answer to a singular question: Do Americans believe that the right to a decent home is part of what it means to be an American?

Back in the 1980s, Dale Maharidge and Michael Williamson rode the rails with the "new hobos" of the time; they began their project

in Youngstown, a short distance from the now shuttered Lordstown plant, chronicling the death of the steel industry. At one point, according to Maharidge himself, he and Springsteen snuck into an abandoned steel mill, "hoping the guards" didn't catch them "and have us thrown in jail." At least two of the songs, "The New Timer" and "Youngstown," on Springsteen's 1995 *Tom Joad* emerged from his relationship with the two men.

Springsteen's "Youngstown" is a searing and angry portrait of a dying steel town. When steel was in demand, Youngstown flourished. From the Civil War to World War II, the factories churned out molten iron and steel and other materiel that was used for the tanks and other equipment in both world wars, the Korean War, and the Vietnam War. But eventually higher manufacturing and shipping costs and fierce competition took their toll on the city. It was the beginning of the end for Youngstown.

Published in 1985, Maharidge's *Journey to Nowhere* is about the new homeless, those left behind by Reaganomics, globalization, deindustrialization, and the subsequent inequality and who never lived on the street before, those who thought that work would always be there as it had been for their parents and grandparents. Years later, the songs on the album still resonate; the stories still ring true. As media reports have indicated, homelessness is once again on the rise in the United States.

Tim Ryan grew up in the Youngstown area. Both his grandfather and his great-grandfather worked in the Ohio steel mills. When he won Ohio's Democratic primary in May 2022, his acceptance speeches contained Springsteen-esque echoes. "We have to love each other, we have to care about each other, we have to see the best in each other, we have to forgive each other," he said. In fact, during his unsuccessful 2022 run for the U.S. Senate seat in Ohio, his stump speeches sounded as if they were lifted from a Springsteen song. His opponent in the race was J. D. Vance.

Vance, of course, became famous after the success of his surprising best-seller *Hillbilly Elegy*, about growing up poor in Middletown, Ohio, that was adapted into a less successful film costarring Amy Adams and Glenn Close, the latter in an Academy

Award–nominated performance as his fierce but beloved grandmother. While reading *Elegy*, one was never quite sure—I was never quite sure at least—where Vance stood politically until he emerged, or reinvented himself, as Amy Davidson Sorkin put it in the *New Yorker*, as "a MAGA man." But the hints were there all along scattered in bits and pieces throughout the book. "As a culture," he writes at one point, "we had no heroes. Certainly not any politician." Later he writes, "Public policy can help, but there is no government that can fix these problems for us."

For decades, the Northeast and Midwest manufacturing regions voted Democratic, until they didn't. The passage of the North American Free Trade Agreement (NAFTA) in 1993 and the acceptance of China into the World Trade Organization in 2000 changed all that when manufacturing plant after manufacturing plant began to close. As it turns out, free trade, and all the hope that it was supposed to represent, was ruinous to America's manufacturing industries in Ohio and elsewhere. In the early years of the twenty-first century, about 3,500 manufacturing businesses closed in Ohio alone. By 2010, the population of Youngstown had fallen 60 percent from its 1930 peak. Now it is one of the poorest cities in the country. Similarly, like Springsteen's Freehold, Vance's hometown of Middletown also fell into disrepair in the 1970s and 1980s. Industrial jobs disappeared, its main street stores shuttered. People began dying not from natural causes but from drug overdoses. The opioid crisis was in full bloom.

When *Hillbilly Elegy* rose to the top of the best-seller charts, pundits and television broadcasters turned to Vance to help the rest of the United States better understand why so many people had turned to Trump for solace. For a time, Vance—the ex-Marine, Yale Law School graduate turned venture capitalist—became the unofficial spokesman for the white working class even though nobody really knew his party affiliation, especially since he had once described Trump as an "idiot" and didn't even vote for him. (He later welcomed Trump's endorsement.)

Joshua Rothman in the *New Yorker* described Vance's life as "an immigrant story." Vance referred to himself as a "cultural emigrant." Despite being born and raised in the United States, Vance felt profound feelings of dislocation. Writer Rod Dreher in the same piece mentions Kevin D. Williamson's essay in the *National Review* that downward-bound communities "deserve to die" since they have two strikes against them: they are "negative assets" and are morally "indefensible." Williamson even goes as far as to reference Springsteen in his piece but not in the way that Springsteen fans would appreciate. "Forget all your cheap theatrical Bruce Springsteen crap," he writes. "The white American underclass is in thrall to a vicious, selfish culture whose main products are misery and used heroin needles. Donald Trump's speeches make them feel good. So does Oxycontin."

Trump aggressively pursued the poor white vote and the broader working-class vote in a way that other candidates did not or could not, or simply chose not to. He tapped into the discontent with political correctness and later the idea of left-wing "wokeness." Voters thought that Trump saw them and, best of all, offered them a rope. It may have been a ruse; it may have been more of a noose than something that could be used to rescue someone, but it was something. Trump, after all, promised to bring back manufacturing jobs. Although most of his promises were broken ones, that didn't stop workers from continuing to believe that he had their backs. He told them he was their champion. And they believed him. They still believe him.

In 1980, the so-called Reagan Democrats, white blue-color workers who left the Democratic Party and unions to vote for Reagan, foreshadowed what was to come. In 2022, Illinois gubernatorial candidate Darren Bailey, who ran against and lost to Democratic incumbent JB Pritzker, appealed to the same type of Trump voters. "He stands for the common everyday person, like Trump did," Mary Kozuszek, a farmer from Downstate Illinois, told the *Chicago Tribune*'s Jeremy Gorner. Many Downstaters used to support Democrats when the party "was for the working man." But an

increasing number of people felt like they were being left behind. "We were all Democrats at one time," said David Kozuszek, another Downstater.

Today's working class is much different from Springsteen's generation or his parents' generation. The same could be said for the Democratic Party. The Democrats, writes David Brooks in the *New York Times*, "is in danger of letting go of an ethos, a heritage, a tradition. The working-class heart and soul the Democrats cultivated through the Roosevelt, Truman and Kennedy years rooted Democratic progressivism in a set of values that emphasizes hard work, neighborhood, faith, family and flag." Today, those values are usually associated with the Republican Party.

Similarly, journalist George Packer in the *Atlantic* insists that working class Americans are "less likely to identify with underdogs like Rocky and Norma Rae" or, he adds, "the defeated heroes of Springsteen songs" than to admire "celebrities who pursue power for its own sake—none more so than Trump."

The Democratic Party of old—the party of the so-called Big Tent—was expansive enough to include the likes of New Deal Democrats like Springsteen and conservative southern Democrats like country superstar Toby Keith or even the "common-man Democrat" country icon from Bakersfield, California, Merle Haggard, as singer Rodney Crowell referred to him in Chris Willman's book on politics and country music, *Rednecks & Bluenecks*. But those days seem long ago.

With this in mind, it would be difficult to think of performers more different from each other than Keith and Springsteen and yet, upon reflection, there is some overlapping that is worth noting. Both use class politics in their songs although from vastly dissimilar perspectives.

Keith, who died from stomach cancer in early 2024 at age 62, released several politically charged songs, most famously his huge 2002 pro-America hit, "Courtesy of the Red, White and Blue," an emotional response to the 9/11 terror attacks as well as a homage to his war veteran father. Jingoistic in nature it may have been and the

polar opposite in mood and theme of Springsteen's 9/11 album, *The Rising*, both works nevertheless were personal statements from performers that sprang from their individual moral codes. For despite his blustery persona, Keith was more complicated and his songs more nuanced than the red and blue divisions of media reports. At various times, he expressed admiration for both Obama and Trump. A former Democrat, in 2008, he registered as an independent. And he even recorded his own "Jesus" song. Springsteen's "Jesus Was an Only Son" saw Jesus through the lens of a mother who lost her son. In his tongue-in-cheek "If I Was Jesus," Keith sympathizes with the outcasts and broken souls of the historic Jesus, preferring to run around with the poor "and the wrong crowd": in a very Springsteen-esque touch Keith identified mostly with the sinners.

Meanwhile, Trump, a former Presbyterian who now self-identifies as a non-denominational Christian, was making inroads with evangelicals. Trump's almost messianic campaign rallies—a strange combination of bombast and revelry—began to increasingly look more like tent revivals. To some he is the reincarnation of both John Wayne and Mel Gibson's William Wallace. It makes sense if you look at it as a strictly transactional relationship. In exchange for their support, the evangelicals get what they want: lower taxes, abortion restrictions, and conservative judges.

In 2020, Trump won 84 percent of the white evangelical vote. Evangelicals call Trump God's messenger, God's chosen one to save America from itself. If in 2016, Trump—the billionaire son of a Scottish immigrant (his Gaelic-speaking mother was born on the Isle of Lewis)—declared he was the voice of the working class, in 2023, he went a step further by announcing he was their warrior and protector of Christian values. But there was more. "And for those who have been wronged and betrayed," he said, "I am your retribution."

Not surprisingly, Trump supporters pledged their unswerving loyalty to him. On the issue of his legal woes, for example, one supporter lamented, "I think they are doing the same thing they did to Jesus on the cross." Another supporter, a self-proclaimed evangelical Christian from Iowa, called Trump "our David and our Goliath."

Trump gave people permission to say things and do things that they were already thinking but that they didn't say in "polite" society for fear of being ostracized or for violating social norms. For cultural and sociological reasons, white rural and working-class voters tended to vote against their own interests even though the party they preferred had no qualms about slashing safety-net programs that were designed to help people exactly like themselves. In the 2020 presidential election, Democrats lost white voters without college degrees by 26 percentage points. What's more, they lost places like Representative Ryan's Mahoning River Valley district, a former Democratic stronghold, for the first time since 1972. According to the Pew Research Center, white voters without college degrees accounted for 42 percent of all presidential voters in the 2020 election. Similarly, *Politico* reported that in 2020 Trump won 96 percent of districts where 70 percent or more of voters were white and fewer than 30 percent were college educated. If Tim Ryan, a former college football quarterback and Ohio Everyman, could not convince enough Buckeye voters to turn Democratic then presumably no one could.

For years Congressman Ryan had warned his fellow Democrats of the failures of free trade and globalization. His message was getting through—that government intervention was necessary to circumvent regional decline—but just not enough to break down the stubborn red wall. His goal was to rebuild the middle class and have former Democratic voters return to the fold. Like Springsteen, Ryan's white Catholic working-class heritage is of mixed Irish and Italian. Both his grandfather and great-grandfather worked in the Ohio steel mills. Ryan was perhaps the last of a Democratic breed in Ohio. His message resonated, but it had come too late. Vance won by a significant margin, confirming a Trumpian turn in Ohio and the continued evaporation of working-class, pro-Union Democratic politics in the Midwest.

Meanwhile, though, in neighboring Pennsylvania, another politician with the common touch, John Fetterman, had better results, beating another celebrity office seeker, Dr. Mehmet Oz. Fetterman, like Ohio's senator Sherrod Brown, is an example of progressive

populism done right. Whereas Brown is the exception in Ohio, Fetterman may well be the future in the Keystone State. At his election party, Fetterman struck a Springsteen-esque note: "For every job that's ever been lost, for every factory that was ever closed, for every person that works hard but never gets ahead, I'm proud of what we ran on." Voters were inspired by his health struggles—he suffered a near-fatal stroke in May 2022. "I can identify with Fetterman. I can't identify with Joe Biden," said one voter. Fetterman won by more than 180,000 votes out of more than five million cast, including wins in red-leaning rural counties such as Westmoreland, Erie, Washington, Fayette, Butler, Beaver, and Indiana.

Ironically, as some critics have observed, Springsteen's fan base and Trump's voter base intersect with each other and partly appeal to similar demographics: white, working class, older, urban, although not exclusively so: two very different men admired by some of the same people. In September 2022, a *New York Times* / Siena College poll reported that 59 percent of white working-class voters said Republicans were the party of the working class, compared with 28 percent who chose Democrats. In many ways, Springsteen was and still is the bard of these left-behind whites, the same people who voted for Trump and supported Vance, but Springsteen was singing and writing about the left behind before the term was common usage. As chronicler of the demise of the American working class, and a true-blue New Jersey troubadour to boot, Springsteen hasn't changed his political stripes. His fan base (partly) has.

In recent years, various writers have written books and articles about the left behind and the financial chaos created by the pandemic, both in the United States and elsewhere. In *Hillbilly Elegy*, Vance writes about the special shame associated with white poverty. A few years later, in *Heartland*, Sarah Smarsh discussed much the same thing but with a greater sense of sympathy and kindness and came to an entirely different conclusion. Both Smarsh and Maharidge write eloquently about classism. Maharidge calls it "the great class disparity." In 1991, he wrote an op-ed piece for the *New York Times* on the issue. Observing the panhandlers on city streets, he saw them not as people to be ignored or swept under the rug but

rather as visual reminders of a greater societal problem. "When we close our eyes at night we sweep them from our sight," he wrote. "But they will not go away."

Smarsh offered a very personal take on poverty. Rural poverty.

Smarsh was born in 1980, the year that Springsteen released *The River* and two years before *Nebraska*. In her excellent memoir *Heartland*, she recalls the first time she danced was to her mother's 45-rpm single of Springsteen's "I'm on Fire." The song may be about longing and sexual desire, but she most remembered tangible objects: a dull knife, sweaty sheets, and freight trains. With its tales of geographic disfranchisement and its dismay over stubbornly stagnant wages, Smarsh's memoir actually reads like a Springsteen song. She even writes about driving home from a local bar one evening on a long stretch of country road trying to avoid a state trooper.

Smarsh grew up in Kansas in the 1980s and 1990s. Life, as she remembers it, was a constant struggle, but somehow she was able to maintain her dignity. Just because you earn less than some people, she thought, doesn't mean that you are less. And yet that was the attitude that she confronted throughout her life. She came of age during the "farm crisis." During the first decade of her life, rural Kansas, she notes, "lost about 40,000 residents, while Kansas metro areas gained about 150,000." Everywhere she turned, businesses were shutting down or moving elsewhere: department stores, hardware stores, restaurants.

Class is a major theme in the book. "When I was growing up," she remembers, "the United States had convinced itself that class didn't exist here. . . . Class was not discussed, let alone understood." As she notes, class involves the very being and fabric of people's lives: the way they talk and think and what kind of entertainment they watch and even what kind of foods they eat. She very rarely saw her experience portrayed accurately on television or in movies. The characters may have looked like her, but they did not act like her. "The middle-class white stories we read in the news and saw in movies might as well have taken place on Mars," she writes. And when she did see people like her they usually were little more than caricatures.

For Smarsh and her family, the American Dream that she heard about and read about was elusive, forever beyond her reach. People may work hard every day of their lives, but ultimately they had very little to show for it. The money that took so long to earn evaporated like water off a fast-moving stream. It was gone almost as soon as they put the coins and bills into their pocket.

When Springsteen was becoming aware of Woody Guthrie and reading Steinbeck's *Grapes of Wrath*, Smarsh and her family were living the same kind of existence that the fictional Joad family experienced all those decades earlier. The difference was that the rest of the country didn't know about it or didn't pay attention or care. They didn't know or were not aware that families like Smarsh's even existed "when in fact we just existed in places they never went." Flyover country was the term that was used. In *Dakota: A Spiritual Geography*, Kathleen Norris referred to the Dakotas as "this vast ocean of prairie." The farm crisis in the 1980s created a never-ending number of ghost towns. Farmers in the Plains went bankrupt, or if they managed to hold on long enough to sell the farm, their children, seeing the writing on the wall, sold everything off and moved to the city. It was a dreadful example of rural flight, a situation that remains to this day.

Smarsh was not only born poor. She was born poor and white, which, she believes, brings with it a very different kind of poverty. In a society that conflates whiteness with power, Smarsh felt a sense of otherness: "[B]etter-off whites hate poor whites because they are physically the same—a homeless white person uncomfortably close to a look in the mirror."

On her luminously gritty album, *Midwest Farmer's Daughter*, singer-songwriter Margo Price sings story-songs about people living on the margins, about hard times in small-town and rural America, about loss and heartache and the emotional and physical cost of too much boozing and (barely) getting by. It's the aural equivalent of Smarsh's *Heartland*.

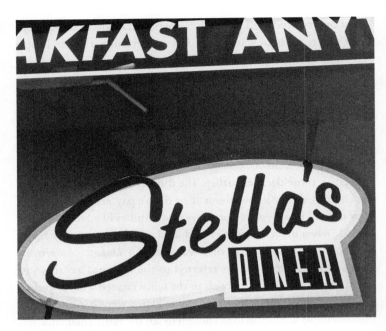

Stella's Diner (Chicago)

CHAPTER 8

An Absence of Things

If Springsteen has an equivalent in the art world, it would be Thomas Hart Benton, the midwestern regionalist who is often placed in the same artistic realm as his fellow midwesterner Grant Wood as well as New York iconoclast Edward Hopper. Springsteen's songs combine elements of all three of these artists: Benton's rough democracy, Wood's honorable simplicity, Hopper's dark alienation.[1] Benton is best known today for his murals and the depiction of everyday people at work, whether toiling in fields or laboring in factories. He depicted ordinary people doing ordinary things with an emphasis on manual and industrial labor: cotton pickers, steelworkers, beer makers.

Benton was devoted to American democracy as much as Springsteen is, his work just as sympathetic to the workingman and workingwoman. Benton tried to find and create meaning in his paintings. At various times throughout his career he would drive around the United States to observe people in their natural surroundings. He devoured books by Thoreau, Whitman, and Twain and even taught himself to play the harmonica. At a party in New York during one particularly memorable evening, according to Justin Wolff, Benton assembled a string band that included, among others, Charles Seeger (father of Pete) on guitar. The men soon realized they had a common interest in Appalachian music. Both Benton and Seeger, for example, admired Appalachian banjoist

and ballad singer Dock Boggs. To Benton, folk and country music epitomized the essence of the American experience.

In 1940, Benton spent some time in Los Angeles where he created an ad campaign for John Ford's movie adaptation of John Steinbeck's *Grapes of Wrath*, which he called *Departure of the Joads*. In works like *Boomtown* (1928), *Arts of the West* (1932), *Huck and Jim* (1936), *Frankie and Johnny* (1936), and his last major piece *The Sources of Country Music* (1975), Benton portrayed Americans as salt-of-the-earth people. The latter featured over a dozen figures: fiddlers, guitarists, dulcimer players, an African American man playing the banjo—they all represented, in his mind, a larger American epic.

In 1935, Benton was commissioned to paint a mural depicting the social history of his native state, Missouri. Completed the following year, the work raised a ruckus, especially among politicians who were not pleased with Benton's choice of subjects, which included the traditional woman-wronged story of Frankie and Johnny but also Jesse and Frank James robbing a bank and a railroad. The mural also included various scenes of pioneers and frontier types as well as such Missouri legends as Huckleberry Finn and his African American friend Jim. It is full of violence and bloodshed, but it is indicative of the robust democratic values that Benton espoused: the exploits of Frankie and Johnny and the James Gang, thought Benton, better illustrated the reality of life in Missouri "than do anybody's opinions about the Constitution."

In 1973, the Country Music Foundation in Nashville commissioned Benton to create *The Sources of Country Music* for the Country Music Hall of Fame and Museum. Benton finished it two years later, just before he died from a massive heart attack—but before he was able to apply his signature to the painting. The figures in the painting were based on people he met on previous trips to the Ozark Mountains in the 1920s and more recent visits to Missouri.

Comparisons can also be made between Springsteen's work and two other iconic American paintings, Grant Wood's *American Gothic* and Edward Hopper's *Nighthawks*. Both are part of the permanent collection at the Art Institute of Chicago.

Wood's *American Gothic* makes a subtle nod to the tradition of nineteenth-century photography where proud owners on the frontier often stood solemnly outside their modest dwellings. In Wood's case he placed two figures—a man and a woman—in front of a small house in Eldon, Iowa. The woman was Wood's sister, Nan, the man a local dentist, Byron McKeeby. Significantly, they did not pose together. Instead, they came together in Wood's studio; he completed the work in two months.

According to Steven Biel, Wood saw the house in August 1930 while driving through Eldon. Attracted by its simplicity, a Carpenter Gothic style of midwestern architecture that seemed both timely and timeless, he created a work of art that was American in look and feel while riffing on the stone Gothic churches of Europe. The modest structure still stands on Route 16—now called the American Gothic Parkway—at the corner of American Gothic and Burton streets.

The figures have been parodied and mocked so many times over the years that it is sometimes difficult to understand how significant they were in their day. The man carries a pitchfork and wears overalls; the woman dons an apron. There is nothing particularly special about them. What makes them special is their very ordinariness: their workaday clothes, emblematic of ordinary life. To viewers and critics alike, these hardy and stoic types evoked America's Puritan ancestors in the same way that other similar figures in popular culture at the time became visual icons of the common people and the honorable labor they engaged in, from Woody Guthrie's *Dust Bowl Ballads* to John Ford's film adaptation of Steinbeck's *Grapes of Wrath*. Stern and unyielding they may have been, but over the years, for many, they came to embody the national character and the essence of the nation itself: its individualism, its Emersonian self-reliance, its natural toughness. They were the Tom Joads of the art world. (Ford's film continues to resonate in twenty-first century America. During his 2023 tour and as part of his performance, John Mellencamp showed a half-hour film that featured clips from classic American movies, including *The Grapes of Wrath*.)

On the other side of the artistic coin was the urban imagery of Edward Hopper. Gordon Theisen, author of *Staying Up Much Too Late*, calls Edward Hopper the "heir to an American Protestant (Puritan-style) sense of isolation, the belief that each man must face God alone." If Hopper were a character in a Hollywood Western he would resemble Clint Eastwood's Unnamed Stranger in *High Plains Drifter* or the Man with No Name in Eastwood's "spaghetti" Westerns or perhaps even Kevin Costner's aloof businessman/rancher turned governor John Dutton in *Yellowstone*. In Hopper's America there was no Promised Land, no New Jerusalem. Just emptiness and isolation.

Hopper and Springsteen were political opposites. Springsteen comes from the FDR Democratic tradition, while Hopper was a lifelong conservative Republican and vehemently against the New Deal, as Christopher Benfey noted in the *New York Review of Books*. "Anyone but that jackass, even Shirley Temple," Hopper wrote, referring to Roosevelt's successful 1936 reelection campaign.

Typically Hopper's America was not set out West but rather back East—mostly in urban settings or occasionally among the rocky outposts by the wild Atlantic. The lonely diners and desolate corners of the American land formed his preferred milieu. And no other American painting quite captures that deep sense of bone-weary solitude as Hopper's *Nighthawks*.

Culturally, diners are seen as democratic, egalitarian, and classless places where everyone is treated the same and waitresses invariably named Madge or Flo or Stella wear a uniform with a name tag and dispense their hard-earned wisdom to strangers and friends alike (think of the characters in Martin Scorsese's *Alice Doesn't Live Here Anymore* or consider the album cover of Supertramp's *Breakfast in America* where model Kate Murtagh, dressed as a cheery waitress named Libby, holds a glass of orange juice in one hand and a tray in the other).

Ostensibly, diners are as quintessentially American as Springsteen himself, and he features a few of them in his songs. In "Open All Night" on *Nebraska* the singer meets Wanda working behind the counter "at the Route 60 Bob's Big Boy." In "Long Walk Home" on

Magic, the local diner is shuttered and boarded up. On the same album, Frankie's Diner in "Girls in Their Summer Clothes" fares better, its neon sign spins round and round "like a cross over the lost and found." It's a beacon in the American landscape.

Diners welcome regulars and strangers. They are transient yet reassuring because no matter where you happen to be in the United States they are there. Most every diner has the same type of food: burgers, fries, eggs, pies, and coffee. And yet, as Theisen notes, the pallid green color of the diner in *Nighthawks* and its self-contained inhabitants evoke the deep pessimistic strain that runs through much of American pop culture, from *Moby Dick* to *Nebraska*. It also echoes the sparse prose of Ernest Hemingway, the pulp novels of James M. Cain, the muscular stories of Jim Thompson, and the movies of Martin Scorsese and Quentin Tarantino. The late art critic Peter Schjeldahl has referred to Hopper's "slight but profound epiphanies of ordinary life." Like *Nebraska*, the great theme of *Nighthawks* is not so much loneliness as solitude. Both works of art symbolize America's innate belief in individualism and self-reliance: people living atomized lives among others but never really connecting with each other. Hopper, like Springsteen, was also interested in the absence of things: what's not there, what's missing.

Whether people or objects, Hopper's subjects are rarely moving. They tend to be stationary as if stuck in some kind of nihilistic existential plane. *Gas* (1940) depicts an isolated gas station with a Mobil sign and bright red gas pumps tended by a solitary balding man in vest and tie. In some ways *Gas* is indicative of Eric Meola's striking black-and-white photograph of Springsteen outside a gas station somewhere in the nocturnal Nevada desert, sitting against the station's blindingly white wall, his convertible adjacent to the pump. The photo has a fascinating backstory.

Meola had Robert Frank's photographs in mind, in particular Frank's seminal 1959 book *The Americans*, when he went on his road trip with Springsteen during the summer of 1977. One of Frank's photos especially resonated with him: the image that Frank took of an endless road on Route 285 in New Mexico with a distant car on the horizon. By intentionally shooting in black-and-white, Meola

hoped to evoke the same bleak, melancholy look for Springsteen's 1978 album *Darkness on the Edge of Town*. A few years later, in 1982, *Nebraska* was released. Meola's *Darkness* photos also resemble the iconic *Nebraska* album cover: big, bold, blood-red lettering framing a black-and-white photograph that David Michael Kennedy took on a flat highway in a barren and bleak winter landscape as shot through the windshield of an old pickup truck.

A Swiss native, Robert Frank arrived in New York in 1947. Eight years later he traveled across the country in a secondhand Ford Business Coupe. When he set out on his journey, he had no idea what he was looking for or what he would find. He took images of the kinds of things that interested him: factories and refineries and such, often located in former boomtowns or in the middle of nowhere. All he took with him were maps, Leica cameras, and, according to Nicholas Dawidoff, "tips from his friend Walker Evans about locations in the Carolinas. His companions were a car radio, a bottle of French brandy, and 'occasional hitchhikers.'" Altogether, he took eighty-three photos.

Chasing the ghost of Elvis, who died five days earlier, on August 16, 1977, Springsteen and Meola (along with Steven Van Zandt) went on their Robert Frank–style road trip out West, first flying to Salt Lake City and then driving into the hot desert night in a red 1965 Ford Galaxie 500XL convertible. They stopped at a gas station in Valmy, Nevada (population 37) on old U.S. 40 that was owned by a man named Eugene DiGrazia at the time. Called Valmy Auto Court, it was housed in a former miner's shack dating to the turn of the twentieth century. At various times it served as a general store, post office, Shell station, Greyhound bus depot, and even a small inn. On the Snap Galleries website, Meola describes the station as "lit by neon like an Edward Hopper set-piece."

Springsteen's stark figure symbolizes his career at the time—in limbo. He had reached a liminal moment in between albums, in between locales, in between relationships, his life somehow situated between departure and arrival, between what happened before and the uncertainty of what was going to happen next. He was on the threshold of something bigger although he didn't

know it yet. Miraculously and unintentionally, Meola's photo perfectly captures that in-between moment.

The photographs were eventually used years later in *The Promise: The Making of Darkness on the Edge of Town*. Meola called the Valmy photo "Daddy's Garage."

Springsteen loves movies, especially genre films such as *Thunder Road*, *The Postman Always Rings Twice*, and *Mean Streets*, to name just a few. In "Backstreets," the narrator asks his friend Terry if he remembered all the movies they watched growing up "trying to learn to walk like the heroes." But one film in particular stood out and stuck in his mind during the writing of *Nebraska*, John Ford's *The Searchers*.

The Searchers stars John Wayne as Ethan Edwards, a Civil War veteran whose niece is abducted by Comanches. The bulk of the movie is devoted to the search for the missing niece. During the course of the film, five years elapse. The niece is now an adolescent and thoroughly assimilated as a Native American. This infuriates the openly racist Edwards—he would rather see her dead than as a Comanche. Ultimately, Edwards rescues and carries her to safety and returns her to her birth family. At the famous conclusion, a doorway frames Wayne's distinctive silhouette. He stands by a threshold—civilized society—that he can't quite cross. He is the perpetual outsider tainted by violence and caught on the wrong side of history. "Western heroes were lonely. They were never fathers, never husbands, always passing through," Springsteen told Barack Obama in *Renegades*.

The Ethan Edwardses of the world are the types of characters that Springsteen has been writing about for decades, and for a short period—post–*Darkness on the Edge of Town* and pre-*Nebraska*—it was possible that Springsteen himself could have fallen into this abyss. English journalist Ray Coleman, in the November 15, 1975, issue of *Melody Maker*, asked Springsteen what he would have done if he had not become a musician. His answer was telling even if said tongue in cheek. "Probably done something crazy," he said. "Maybe robbed stores or something! That always appealed to me, robbing things."

Two neo-Westerns recall the last iconic image of *The Searchers* and reflect too on a common Springsteen theme: isolation.

Brokeback Mountain's doomed love affair between the taciturn Ennis Del Mar (Heath Ledger) and the outgoing Jack Twist (Jake Gyllenhaal) is a prime example of Western isolation. Ennis and Jack are part of what *Brokeback* author Annie Proulx calls the Great Western Myth. Ennis is not a romantic cowboy by any stretch but rather a mere ranch hand. On the other hand, Jack is a rodeo rider. Rodeo riding was not considered real cowboying but a performative approximation of it. As Larry McMurtry, the late unofficial poet laureate of the West, noted, the beauty and grandeur of the Western myth ignores "the harshness of the lives of the people who live in the blank little towns and have to brush the grit of the plains off their teeth at night." *Brokeback* is about those "blank little towns" that are so numerous in the Springsteen canon.

At the conclusion of *Brokeback Mountain*, the camera pulls away to reveal a field of yellow flowers under mountains and a wide-open Wyoming sky. On the back of Ennis's closet door are two shirts, one that belonged to him, the other to Jack, and on a wire hanger suspended from a nail is a postcard of the eponymous Brokeback Mountain. Jack's dark blue denim shirt is tucked inside Ennis's own checked shirt: shirts as mementos, as a memory of unspeakable loss. When McMurtry and Diana Ossana were adapting Proulx's short story, they had the photographs of Richard Avedon in mind (in 1985 he published *In the American West*). From 1979 to 1984, Avedon and his team of assistants spent six summers in places like San Antonio and Butte, Montana, staying in cheap motels while seeking out ordinary people to photograph. Although Avedon was best known as a fashion photographer, he also created salt-of-the-earth portraits and captured the stark reality of life as lived by the factory workers, ranch hands, cowboys, drifters, miners, and waitresses of the American West, visiting state fairs, rodeos, carnivals, coal mines, and prisons.

In Chloé Zhao's Academy Award–winning 2020 neo-Western *Nomadland*, isolation is also a persistent theme. A middle-aged wanderer named Fern (played by a stoic Frances McDormand) and her fellow nomads—a tribe of modern vagabonds—crisscross the country searching for work, momentarily staying long enough to toil in the beet fields of North Dakota, a campground in

California, Amazon warehouses in Texas, and the famous Wall Drug in South Dakota.

The documentary-like feel of *Nomadland* is based on Jessica Bruder's nonfiction book of the same name: about modern-day equivalents of the late nineteenth-century, early twentieth-century homesteaders. Like the homesteaders, these nomads are pioneers in their own right. They are frugal and desperate, battered by rising inequality and a frayed safety net, much of which relies on GoFundMe and other similar services, and where the daily task of living has become unattainable. They do what they can by cobbling work together within the precarious gig economy. Zhao's West contains some of the images we come to expect: wide-open vistas under big skies; but it also features constrained, tightly fit images of parking lots and soulless fulfillment centers.

At the moving climax of *Nomadland*, Fern returns to the company town of Empire, Nevada, now little more than a ghost town since the gypsum mine closed, and to her former house where her husband died. Echoing the final scene in *The Searchers*, Fern, like Wayne's Ethan Edwards, is framed by Zhao's camera as she looks out at the bleak landscape, her future just as uncertain.

Ethan Edwards, like the Charles Starkweather figure in "Nebraska" and other misfit characters, is unfit to live in civilized society. Looked at from another angle, one could argue that Edwards and the male characters that Springsteen has created are variations of Springsteen's own taciturn father, Douglas. Novelist Jonathan Lethem's description of John Wayne, as quoted in Glenn Frankel's film biography of *The Searchers*, could easily apply to many American men of Douglas Springsteen's generation: "His persona gathers in one place the allure of violence, the call away from the frontier, the tortured ambivalence toward women and the home, the dark pleasure of soured romanticism—all those things that reside unspoken at the center of our sense of what it means to be a man in America."

Springsteen's rogue gallery of characters were modeled not only on *The Searchers*' Ethan Edwards but also on the various frontiersmen, highwaymen, adventurers, and pioneers who populated the American West.

Country Road (southern Wisconsin)

CHAPTER 9

Jersey Cowboy

Why don't you go west to California? There's work there, and it never gets cold.
—John Steinbeck, *The Grapes of Wrath*

Part of Springsteen's musical—and emotional—evolution has been the expansion of his musical palette. There is a musical genre in particular—apart from rock—that resonates with Springsteen and that is worth exploring at length: country. Country and religion go hand in hand, of course, but how about country and politics? Specifically, Springsteen's left-wing politics? Do they have anything in common?

Aside from a few country outliers, the genre mostly is associated with right-wing politics or, most often, with no political allegiance at all. And at first blush, it might seem less than surprising that a strong bond exists between Springsteen and country music. He was, after all, raised in a part of Freehold, New Jersey, that was given the nickname "Texas" because of the significant number of migrants from Appalachia who had settled there.

But consider that a large part of Springsteen's evolution as a songwriter has been his interest in learning about the roots music of America or what is now called Americana. You don't have to be an American to sing Americana. Anyone can sing Americana.

Americana is a broad term that covers a large swath of musical territory, including folk, alt-country, traditional country, bluegrass, and gospel, among others. Over the decades Springsteen has been a serious student of this music even before it had a name. Delving deeply into the classic country and folk songs, from Hank Williams to Woody Guthrie, helped to change his perspective on what music could be and helped him realize that he too could write songs that addressed the universal condition.

In early 2013, Springsteen revealed that he had been working on an album of country songs that he had set aside (more about his "country" album later). I would argue that Springsteen is among the finest country lyricists in rock. Indeed, there is a reason why Nicholas Dawidoff has called Springsteen a "Rust Belt version of the Man in Black." Like the best of country, Springsteen writes plainspoken words that say profound things not only about the American condition but also about the human condition.

Country singer Emmylou Harris once referred to Springsteen as being "more of a country poet because of the way he phrases, the simplicity and passion of what he does—it's country even if it doesn't have a pedal steel guitar." Springsteen told *Mojo* magazine in January 2006 that he was "a child of Woody and Elvis." He didn't begin to consciously write adult songs until after *Born to Run*. "I wanted to make the characters grow up," he explained. In fact, he didn't seriously pay attention to country music until he was in his midtwenties when he listened to Hank Williams and Jimmie Rodgers as well as George Jones, Charlie Rich, and the Louvin Brothers. He was inspired by the depth and darkness of the lyrics; country music appealed to him because, he said, "Country was provincial, and so was I . . . country was about the truth emanating out of your sweat, out of your local bar, your corner store."

Springsteen sings about the lives of ordinary working folk. In this way his best songs evoke the timelessness of the best country songs. Traditional country is the music of pre–rock and roll, written in plain language that expresses the collective pain and joy of working-class people even as it articulates their collective hopes and

dreams. Bryan Garman has a name for it: hurt songs.[1] Springsteen also sings hurt songs, but he also confronts a taboo subject, class, in ways that few others have done outside country or folk music. Indeed, Springsteen writes and sings songs of class consciousness, mostly unheard of in popular music aside from hip-hop (with Joe Strummer of the Clash, Steve Earle, Jason Isbell, and Billy Bragg being a few exceptions).

If, as Dana Jennings writes in his wonderful book about the golden age of country music, *Sing Me Back Home*, the best country music is "prayer and litany, epiphany and salvation," some of the best Springsteen songs hang on a country skeleton. Country music is the music of rural America—the white man's blues—in the same way that Springsteen's songs are the music of urban working-class America. The stoic realism of Merle Haggard's "Workin' Man Blues" sounds like something straight out of the Springsteen songbook. Country's subtext is class just as Springsteen's subtext is class and politics.

Springsteen's country influences are profound even if he hasn't written many cheating or drinking songs, the stereotypical themes of country music. Like Elvis Presley, Hank Williams, Jimmie Rodgers, Johnny Cash, and Merle Haggard, to name just a few, Springsteen, for all his onstage affability, is, at heart, an outsider, a loner. And like Elvis, with his long sideburns and flamboyant clothing, Springsteen felt different growing up, a stranger—a rank stranger, to use a common country phrase—in his own hometown and even in his own family. The first record he bought was *Jailhouse Rock*. It bears repeating. He identified with Elvis on so many levels, not only as a performer—when he saw him on *The Ed Sullivan Show* he knew he wanted to be like him—but also through a class-conscious lens. "I was somebody who was a smart young guy who didn't do very well in school. The basic system of education, I didn't fit in; my intelligence was elsewhere."

For centuries, the West was considered the Promised Land. It went by plenty of names: the land of Cockaigne and the Big Rock Candy

Mountain where, to quote Harry McClintock's famous hobo fantasy, "the hand-outs grow on bushes" and the sun shines every day, a land of cigarette trees and lemonade springs.

The West spoke to Springsteen as a young boy. He was taken by its vastness, its openness, its promise. Even if he could not quite articulate it, he could feel it. He would go there one day, he told himself—and he did—but he would not stay there. Like many of the pioneers, outlaws, and homesteaders who preceded him, the West became a temporary refuge, a respite, a sanctuary from whatever demons had taken hold. But in some profound and mysterious way, it would always be the Promised Land, if only in dreams.

As a child, Adele, his doting mother, recited by memory the story of *Brave Cowboy Bill*, a children's book by Kathryn and Bryon Jackson. It stayed with him. Years later he would write his own children's story first as a song and then as a children's book illustrated by cartoonist Frank Caruso, although it was more like a short graphic novel with adult themes, a Western epic he called *Outlaw Pete*. *Outlaw Pete* was based on the song that appeared on *Working on a Dream*.

At eight minutes in length, "Outlaw Pete" is one of Springsteen's longest songs. It covers familiar territory. It's about a man trying to "outlive and outlast his sins," Springsteen says. Pete carries his past with him always. The adult Pete prays to Jesus, sees a vision of his own death, and marries a Navajo girl. When Pete kills the bounty hunter who has been chasing him, he rides and rides the biblical sum of forty days and forty nights.

As far back as the early 1970s, Springsteen was writing cowboy-themed songs, some of them steeped in wild, surrealistic imagery. He played "Cowboys of the Sea" at his audition for Columbia Records' John Hammond in 1972. Pulling images and metaphors from pop culture, movies, and tall tales ("They ride beneath the waves at twenty-thousand leagues / On stallions stitched to seaweed strands"), he sang about the Texas Rangers and the "deep sea desperadoes" who ride off into the "blue sunset." It's a coherent mess, but it's fun to listen to.

Another early cowboy song, "Ballad of Jesse James," was written when he was with the Bruce Springsteen Band. The song appears on *Chapter and Verse*, the compilation album released on Columbia Records in 2016 as the audio companion to Springsteen's memoir, *Born to Run*. He would return to Jesse James again when he recorded a rendition of "Jesse James," the nineteenth-century American folk song on *The Seeger Sessions*.

Few artists offer radical interpretations of their own work, especially their most iconic songs.[2] And yet Springsteen has done that over and over again. On *Live in Dublin*, "Atlantic City," "Further On (Up the Road)," "If I Should Fall Behind," "Growin' Up," and especially "Open All Night" and "Blinded by the Light" are virtually unrecognizable. Of the recording's twenty-three songs, eight are reinterpretations and four are Springsteen's renditions of American standards. Three are from *Nebraska* ("Atlantic City," "Highway Patrolman," "Open All Night") and one each from *The Rising* ("Further On (Up the Road)"), *Lucky Town* ("If I Should Fall Behind"), *Devils & Dust* ("Long Time Comin'"), and *Greetings from Asbury Park, N.J.* ("Blinded by the Light"). The rest are songs culled from both versions of Springsteen's *We Shall Overcome: The Seeger Sessions* recordings, including its follow-up, the *American Land* edition.

The record opens with a rowdy version of "Atlantic City." A banjo and a mean guitar play off each other before the full seventeen-member band kicks in. Art Baron's penny whistle introduces "Further On (Up the Road)" as the band reimagines the *Rising* song into a jaunty Celtic jig. The wistful ballad "If I Should Fall Behind" from *Lucky Town* is transformed into a graceful waltz with tinny piano and gentle fiddle that sounds as if it came out of one of those classic John Ford Westerns that Springsteen is so fond of. Although fleshed out a bit with piano and unobtrusive drums, "Highway Patrolman" remains a somber tale of the struggle between two very different brothers. Country meets New Orleans on "Long Time Comin'" with its fiddle, steel guitar, and brass section.

"Open All Night," "Growin' Up," and "Blinded by the Light"—three standout performances on the record—bear little resemblance to the original versions. Springsteen turns "Open All Night" into an extended jam session with boogie-woogie-like rhythms and scat singing from the Sessions band backup singers that is worthy of Louis Armstrong. The slowed-down rendition of "Growin' Up" starts quietly as Springsteen strums an acoustic guitar as he tells his autobiographical tale as if for the first time. Unlike the mumbled and lightning-speed delivery of the original, here he enunciates each word and each sentence, bringing out the Dylanesque qualities of its lyrics. Then the Sessions band joins in with the audience singing along on the one-line chorus. A languid, sensuous "Blinded by the Light"—utterly revamped—has a big sound and is given the full New Orleans–style treatment complete with brawny brass section.

Of the songs that do not appear on either of the *We Shall Overcome* recordings, three are American standards—two spirituals ("When the Saints Go Marching In" and "This Little Light of Mine") and a song originally recorded by Waylon Jennings in 1967 ("Love of the Common People"). "This Little Light of Mine" became a civil rights staple during the 1950s and 1960s. Springsteen and his band offer here a rousing rendition, while on "Love of the Common People" he allows the smooth voice of Curtis King Jr. to take over the lead vocals.

On "When the Saints Go Marching In" Springsteen returns the song to its religious roots. Today the song, considered a jazz and pop standard, is more often associated with marching bands and football teams than with gospel hymns, its spiritual imagery often ignored. Springsteen offers his own makeover, playing up its biblical themes and finding in its haunting lyrics a still-moving song about death, life, and renewal ("I'm waiting for that morning / When the new world is revealed"). And in a post-Katrina world (Springsteen and the Sessions band first performed the song during the 2006 New Orleans Jazz and Heritage Festival), the soulful trumpet solo by Curt Ramm adds an additional layer of poignancy.

Given Springsteen's merging of folk song and politics, is it any surprise that he found inspiration in Pete Seeger's long life and career? Like Seeger, Springsteen sees songs as being tools, "righteous implements when connected to historical consciousness." In Springsteen's case, songs not only are physical connections to his ancestors—musical and otherwise—but also serve as connections to his present-day community and, beyond that, to the nation and indeed the world.

The Seeger Sessions include not songs that Seeger wrote but rather versions of songs that Seeger recorded. Springsteen began listening to Seeger in 1998 when he was asked to provide songs for a Seeger tribute album, *Where Have All the Flowers Gone*. Springsteen did his usual diligent homework, buying as many Seeger records as he could find. "I heard a hundred voices in those songs, and stories from across the span of American history—parlor music, church music, tavern music, street and gutter music—I felt the connection almost intuitively, and that certain things needed to be carried on," he told Alec Wilkinson. In other words, Springsteen found the entire history of the United States in Seeger's songs. He found something else too: a common basic philosophy. Like Springsteen, Seeger believed in the equal rights of all human beings.[3]

Springsteen was nineteen when his parents moved to California with little more than a few thousand dollars and an old car to their name, settling into a small, two-bedroom apartment in San Mateo. But he remained behind in New Jersey. By that time, he felt his future lay in the Garden State since he was already a veteran of the Jersey Shore bar scene. Even as young as fourteen, he began staying out all night, sleeping on the beach after playing in the 5:00 A.M. clubs despite being legally underage. And when he did go out West a few years later to play gigs with his bandmates he couldn't even drive. Instead he sat in the passenger seat. Ironically, the first property Springsteen ever owned was not in New Jersey but in the Hollywood Hills. After spending some time in California, Springsteen and his wife Patti Scialfa returned to New Jersey to raise their

children. "Some are born in their place, some find it, some realize after long searching that the place they left is the only one they have been searching for," Larry McMurtry once wrote.

For generations of Americans, California represented a fresh start. Before the Springsteens headed out West, there were pioneers and frontiersmen, land surveyors and corporate carpetbaggers, missionaries and soldiers, and always the artists (Thomas Moran, Georgia O'Keeffe), the writers (Owen Wister, Zane Grey), and the photographers (Ansel Adams). It was not only the place where you could start over but the place where you could reinvent yourself. Anything was possible. It was the Promised Land *and* the New Jerusalem. "If you tip the world on its side," celebrated architect Frank Lloyd Wright once said, "everything loose will end up in California."

But there was a downside to this vaunted new land. "American individualism, much celebrated and cherished, has developed without its essential corrective, which is belonging," wrote Wallace Stegner, the novelist once called the "Dean of Western Writers." Self-reliance became part of the Western Code itself. In *Bad Land*, Englishman Jonathan Raban wrote about the homesteaders, many of them immigrants like himself, who went to Montana around the turn of the twentieth century to make their fortunes.

The dual philosophy of individualism and self-reliance—those stalwart Puritan/Yankee traits—can be a double-edged sword. Voters have often expressed the essence of the individualism ethos in the bluntest of terms. In early 2023, a Republican voter from New Jersey gushed, "everything was great" under Trump: gas prices were low, the border was contained. "And he got run out of town just because he send mean tweets and has a big mouth." Another voter, from California, complained about too much government interference under Democratic administrations. "We've got so many regulations, taxes and controls and spending. We should have an army, a military. That's about it." On the other hand, author Alissa Quart calls the American go-it-alone philosophy and the "pull yourself up by your bootstraps" individualism a "toxic myth." Rather, she

believes what she calls "the art of dependence" and recognizing the importance of others should be a cause of celebration, not condemnation.

The Homestead Act of 1909 offered generous terms and plenty of land to those hardy souls who were willing to make of it what they will. "Solitaries, sociopaths, compulsive travelers, boys who had failed to grow up found their way invariably west, where they could pass for normal citizens," Raban wrote. "Fear of long-term attachment, to any thing or any body, was not a disability out here, where the peculiar economy of the region depended on a labor force of willing rolling stones." To John Wesley Powell, explorer and geologist, all "a man" needed and all that he could reasonably manage was eighty acres.

The poet laureate of the West, Larry McMurtry explored the myth of the West in works of fiction in *Hud* and *Lonesome Dove* and in works of nonfiction like *Reading Walter Benjamin at the Dairy Queen*. He and other writers have commented on the essential loneliness of the westering experience.

Going west meant mobility, but it also often meant running toward freedom, escaping toward freedom, although as Stegner pointed out freedom could just as often turn into a curse, depriving people of a sense of community and creating a troublesome feeling of rootlessness, cutting off people from memory "and the continuum of time."

Some call it the Western Code, others call it the Cowboy Way, but whatever term one prefers the premise is the same: a live and let live philosophy. It referred to something as simple as a fair handshake. The cowboy respected nature. He was a good steward of the land. A cowboy kept his word. Other traits associated with the cowboy included honesty, straightforwardness, hard work, modesty, and a quaint type of etiquette. And since many of the people who settled in the West originally came from the Midwest and the South, chivalry was an important and enduring characteristic.

Growing up, Springsteen was well aware of this cowboy code. "All of my heroes, going back to the Western heroes, seemed to have a code of life," he told Barack Obama in *Renegades*. He follows a code of his own that is especially evident in his philosophy about performing: "I'm gonna give my best to bring out the best in you." Performing would be his purpose in life. It would be his ministry.

"I take my job seriously," he added. "I believe that I am involved in a ridiculous but noble profession, and that music had an impact on me, changed my life. God has given me this opportunity to come out at night and to have that kind of impact on some individual in the crowd. If I can do, that's worth being on the planet. That's something worth living for."

In 1994, the Jersey cowboy bought a farm in the Garden State's horse country. Years ago, this same Jersey cowboy told fans he was working on a "country" album. As it turns out it wasn't a country album in the sense of, say, a Hank Williams or a Jimmie Rodgers, but more a country and western album, or more accurately a countrypolitan album in the vein of Glen Campbell. With the exception of the failed country singer of "Somewhere North of Nashville," all of the songs on the 2019 *Western Stars* album were set in the American West. But this was not the West of *Tom Joad* or *Devils & Dust*. This was a different West. *Western Stars* told stories of the West as seen through the faded memories and twilight years of the region's stuntmen, drifters, and ne'er-do-well wayfarers.

Sometimes the imagery on *Western Stars* is gorgeously poetic ("A fingernail moon in a twilight sky"); other times it is as realistic and grim as a Dust Bowl photo (motels on a bleak stretch of road). The album cover is Western pastoral. On the front is a horse racing through the Western landscape. On the back is the Jersey cowboy himself: Springsteen wears brown jeans, brown boots, a denim shirt under a brown jacket. And in a classic cowboy pose, his cowboy hat tips down as he leans against a car with California plates.

Much like Springsteen, the West of my imagination was fed by watching Hollywood Westerns and, in my case, reading my brother's

Cowboy Boots and a Bottle of Jack

The boots are lived in
broken and dusty
a bottle of Jack on the counter.
Darkness descending
the sky turns into a deep purplish hue.
He raises his lips
savoring the warmth of the brown liquid
as it soaks his parched throat
like a free-flowing river.
Folks come and go
a nod here, a nod there
a tip of the hat
when words aren't enough.
He jiggles a few coins in the pocket
of his worn-out jeans
old songs play on an ancient jukebox
people and places once forgotten
now vaguely remembered
promises given
some kept, some broken
melodies drift in and out into the
cold Western night
losing track of time
and orders one more shot of
Jack.

—June Skinner Sawyers

collection of *True West* magazines with their thrilling portraits of Billy the Kid and Butch Cassidy and the Sundance Kid.

During the early years of Western settlement—the era of the fur trade, gold rush, and cattle wars—a particular Western kind of democracy reigned: every man for himself. Even today this sentiment still resonates in the post-frontier culture of modern-day Western libertarianism. According to Montana values, for example, Montanans

believe that if your neighbors aren't hurting you, you leave them alone. On the other hand, the outlaw West that promised too much freedom led French-born surveyor, trader, and farmer J. Hector St. John de Crèvecoeur to condemn not only a cruel kind of freedom but also selfishness and a penchant for violence. In the influential *Letters from an American Farmer*, published in 1782, Crèvecoeur famously asked, "What, then, is the American, this new man?"

Western Stars touches on aspects of this post-frontier West. From a musical perspective, though, it is clearly in Jimmy Webb country, the composer who wrote some of Glen Campbell's best songs, including "By the Time I Get to Phoenix," "Galveston," "Wichita Lineman," and the underappreciated "Where's the Playground Susie." In Dylan Jones's wonderful *Wichita Lineman*, Springsteen comments favorably on Campbell's tenor voice. "Pure tone. And it was never fancy. . . . It was simple on the surface but there was a world of emotion underneath." On *Western Stars*, Springsteen tries to capture that purity.

The telephone poles and trees that go "whizzin' by" in "Hitch Hikin'" recall the imagery of Webb's iconic "Wichita Lineman." In "Tucson Train" the singer goes looking for a new life. In other songs, a stunt man who made his living working in B-pictures recalls his glory days when he was "once shot" by John Wayne. Now, his body wrecked by injuries, the best he can do is to be a pitchman for Viagra commercials.

The motel became popular after the development of the Interstate Highway System. The motel has come to symbolize transience and freedom, but it was also associated with various forms of illicit activity. In the last cut, "Moonlight Motel," Springsteen offers his own homage to this peculiar twentieth-century American invention. "Moonlight Motel" also recalls Edward Hopper's 1957 *Western Motel*, with its themes of mobility and the loneliness of the vast Western landscape.

Some writers called Springsteen the Jersey Cowboy years before *Western Stars*. The label may not be as incongruous as one might think. His sister Virginia's husband Mickey traveled the rodeo

circuit from New Jersey to Texas. "Unbeknown to most, Jersey is home to the longest consecutively running rodeo in the United States, Cowtown, and once you hit the southern part of the state, there's more cowboy there than one might think," he writes in *Born to Run*. Actually, Cowtown has been holding rodeo competitions in Salem County, one of the most rural areas in New Jersey, nearly every week since 1955. The events include timed steer wrestling, calf roping, and saddle bronc riding. In total, nearly eight hundred professional rodeos were held around the country in 2022.

Nature writer Gretel Ehrlich contends that the rodeo represents the western way of life "and the western spirit"—even though the sport is often mocked by "real" cowboys. "Rodeo," she writes, "is the wild child of ranch work and embodies some of what ranching is all about." In my view, rodeo combines individualism with teamwork in the same way that the E Street Band combines teamwork with individualism. Another comparison could be made between rodeo cowboys and touring musicians. Rodeo cowboys are on the trail a great deal of the time just as musicians are on the road much of their working life.

In the mid-1990s, Springsteen bought Stone Hill Farm, a three-hundred-plus-acre horse farm in Colts Neck, New Jersey—a short distance from the rented ranch house on the edge of a reservoir where he wrote *Nebraska*. The estate, which was once used for raising cattle and was founded in the early eighteenth century, includes a three-story colonial main house, a guesthouse, and a red barn. (Anyone who has seen the *Western Stars* documentary will recognize the barn.) The Springsteen farm is located only forty-two miles from the heart of Times Square—and only a short ten miles from Freehold, but a world apart.

In recent years, Springsteen has taken up horse riding himself. His wife, singer Patti Scialfa, has been riding horses for years, and their daughter, Jessica, is a notable equestrian: she won a silver medal as a member of the U.S. equestrian jumping team at the 2020 Tokyo Olympics.

Horses have featured prominently in Springsteen's songs. In September 1996, Rumson, New Jersey, resident Fiona

Williams-Chappel, Springsteen's fashion stylist, died of heart failure at the shockingly young age of thirty-seven. Her untimely death served as inspiration for his song "Silver Palomino" from *Devils & Dust*, where a young boy copes with the loss of his mother by lending the wild silver palomino of the title with the free spirit of his mother's soul. More recently, "Chasin' Wild Horses" from *Western Stars* continues the theme, as the narrator equates horses with freedom in the way that a younger Springsteen might have compared cars with freedom.

The reign of the cowboy in the American West was remarkably short-lived. Historically, the era began during the cattle drive in post–Civil War America and essentially ended with the arrival of the iron horse. But Hollywood kept the cowboy alive during the silent era and beyond with such actors as Tom Mix, John Wayne, Clint Eastwood, and Kevin Costner popular on the big and small screens. In politics too American presidents from Teddy Roosevelt to Ronald Reagan and George W. Bush evoked the mythic West in their attitudes, in their speeches, in their very personas. Bush, the Texan with the Yankee pedigree, was eager to be seen in a Stetson hat and cowboy boots, the classic uniform of the American cowboy.

On the big screen, movies as disparate as Ang Lee's *Brokeback Mountain* and Chloé Zhao's *Nomadland* offered a more nuanced portrait of the West. Heath Ledger's taciturn Ennis Del Mar could be an echo of Clint Eastwood's Man with No Name from his trio of "spaghetti" Westerns, a drifter who passes from town to town without ties to anyone or anyplace. In recent years, Taylor Sheridan as writer and director has created his own cottage industry of movies and television series that explore the modern West, including *Yellowstone*—and its prequels *1883* and *1923*—*Hell or High Water*, and *Wind River*. *Yellowstone*'s themes are the themes of the neo-Western: land stewardship, the violent treatment of Indigenous peoples, big business. Sheridan has earned his cowboy spurs, at least. He grew up on a ranch in Texas and breeds and shows Quarter Horses.

To Wallace Stegner the real West was "a melting-pot mixture of people from everywhere, operating under the standard American

drives of restlessness, aggressiveness, and great expectations, and with the standard American freedom that often crossed the line into violence." Westerners had the freedom to kill one another without the long arm of the law to get in the way. It was every man for himself rather than the collective sense of community as associated with, say, the town hall meeting tradition of New England. The mythic West was the West that Springsteen grew up with: the West of antiheroes, lone riders, and men with no name. It was the folklore of toxic masculinity and even toxic femininity since the women of the West often took on the traits of their male counterparts. In this sense, the American story is the story of the Western writ large, the peopling of a so-called wilderness from sea to shining sea despite the inconvenient truth that the land had been inhabited for thousands of years, which meant that the peopling of the land led to the eviction through violent means of the original inhabitants of the land. The Indigenous peoples were the collateral damage of Manifest Destiny.

Debra Marquart grew up in Napoleon, North Dakota (population 1,107). It consisted of three bars, two grain elevators, a post office, a drugstore, a courthouse, and a funeral home and was populated by farmers, bankers, priests, teachers, housewives, and nuns. Here, the promise of open space is more like a prison, she offers, confining its inmates to an uncertain future. Marquart says she was accustomed to people telling her they had never met anyone from North Dakota before. She grew up in what she refers to as a barren and unforgiving land, much of it acquired by newcomers through the Homestead Act. The least visited state in the union, North Dakota is invisible to the rest of the country. "We were all raised under the rough tutelage of the Great Plains," Marquart writes in her memoir, *The Horizontal World*, "a fierce and loving taskmaster."

Kathleen Norris also grew up in the middle of nowhere. In her best-selling *Dakota: A Spiritual Geography*, she refers to where she grew up on the Kansas plains as "America's outback" where there are far more cattle than people. Small towns and hamlets are far apart from one another, separated by miles and miles of empty land.

"On a clear night," writes Norris, "you can see not only thousands of stars but the lights of towns fifty miles away. Scattered between you and the horizon, the lights of farmhouses look like ships at sea." Norris goes on to call this "vast ocean of prairie" a dangerous place where inhabitants have to combat "disorientation and an overwhelming sense of loneliness." Similarly, songwriter Jimmy Webb called the flat Oklahoma country where he grew up "a featureless world, like being on Mars, except for the telephone wires gracefully draping out towards the horizon."

This is also the geographical and spiritual landscape of *Nebraska*, Springsteen's "cowboy" album. "The old joke that cowboys get along better with horses than they do with women is not a joke, it's a tragedy," wrote Larry McMurtry in *Reading Walter Benjamin at the Dairy Queen*. The various murderers, thieves, and misfits on *Nebraska* are also tragic figures: confined in their isolation.

Such tough-minded Western writers as Norman Maclean and Ivan Doig have noted the isolation of the land and the way that the miles and miles of desolation can shape the psychology of its inhabitants. "Nebraska," the song, is a cowboy song of the Great Plains, and the Starkweather figure in it is as lonely as the solitary prairie figure in Jimmy Webb's "Wichita Lineman." The arrangements in the latter may be lush, but Glen Campbell's everyman voice is full of a wistful kind of longing and imbued with an ineffable sadness. In comparison, Springsteen's "Nebraska" is tougher and more brittle, but its sense of melancholy is just as pronounced. Like Springsteen, Webb was also writing about the common man and woman but in a completely different way—rather than the grittiness of New Jersey or the nihilism of *Nebraska* he preferred what he called the "prairie gothic" of the wide-open plains and the existential loneliness of the solitary prairie figure: less Edward Hopper and more Grant Wood.

Springsteen released the *Western Stars* album along with an accompanied documentary film of the same name that he codirected with Thom Zimny. In a surprise move, in the film—but not on the album—he sang a rendition of Campbell's 1975 blockbuster hit, "Rhinestone Cowboy."

Jersey Cowboy

At first glance "Rhinestone Cowboy" may seem like an odd choice for Springsteen to sing, a song so closely linked with Glen Campbell's massive 1975 hit. And yet the subject matter—pursuing the American Dream and being willing to compromise in order to achieve it—resonated with Springsteen. According to Dylan Jones, the song's composer, Larry Weiss, based the rousing chorus on the last scene of the 1944 film *Buffalo Bill*, starring Joel McCrea in the titular role. Buffalo Bill Cody rides out on a white horse "in a star-spangled rodeo," complete in a shiny white suit and sporting a long white beard, like a Western version of Santa Claus, the giver of gifts and wishes.[4]

Despite being a larger-than-life character, Buffalo Bill was a real person with a varied career. At various times he was a soldier in the Union Army, a bison hunter, an Army scout during the Plains Wars, and, most of all, a showman. In 1883 he founded Buffalo Bill's Wild West Show, a circus-like attraction that toured throughout the United States and, a few years later, in 1902 and 1903, in Britain—he even agreed to a command performance for Queen Victoria during her Golden Jubilee—and on the continent. The show featured parades on horseback, cowboys, Native Americans (including, at one point, Sitting Bull), and performers from Annie Oakley to Calamity Jane. Cody, Wyoming, is named after him and boasts a wonderful museum, the Buffalo Bill Center of the West, and the popular Irma Hotel in downtown Cody is named after his daughter.[5]

Years ago, Springsteen wrote his own Jersey version of Buffalo Bill's Wild West Show. "Wild Billy's Circus Story" was part Coney Island's freak sideshow meets *Nightmare Alley*. Full of vivid imagery and a strange and wonderful cast of characters and equally wonderful instrumentation of accordions and tubas, Springsteen's circus show had fire-eaters, sword swallowers, fat ladies, midgets, and human cannonballs. Ballerinas did cartwheels on tightropes, while a lonely man in baggy trousers ran back to his Ohio hometown. The song recalls Springsteen's childhood when the Clyde Beatty / Cole Brothers circus visited Freehold every summer.

Cemetery (Chicago)

CHAPTER 10

Tomorrows and Yesterdays

As the years have passed, Springsteen has been looking increasingly inward at his own life and at the friends he has lost. He has grown more reflective, although even as a young man his songs had an elegiac edge to them. Like Dylan, he has always seemed older than his years. Still, in *Western Stars* and especially *Letter to You* the singer has been examining the past as he has less and less of a future. Between daylight and the dark of day, Springsteen's most recent songs are set in a land of ghosts.

On *Letter to You*, Springsteen grapples with mortality. The songs on the album are written from the perspective of an older man looking back at his life. One minute you're here, the next you're gone. Life comes and goes in a flash. The religious themes and images remain ("I washed you in holy water / We whispered our black prayer"). One of the characters in the songs lies on a bed of thorns. Blessed in his lover's blood, he is "marked by Cain." In "Rainmaker," the narrator's hands are raised to the Old Testament god, Yahweh, "to bring down the rain." In "Ghosts," he pays homage to his ancestors. In the song, he recalls the singer's youth when he bought a Fender Twin from Johnny's Music as he makes his vows "to those who've come before," promising to meet his brothers and sisters "on the other side" even as he proclaims that death "is not the end." Surprisingly, the album includes older songs, "Janey Needs a Shooter," "Thunderclap," "If I Was the Priest," and "Songs for Orphans," that

sound remarkably timely and alive. Springsteen even made a cameo on John Mellencamp's 2022 *Strictly a One-Eyed Jack*. On "Wasted Days," their voices meld together in harmony as they wonder "how many summers still remain? How many days are lost in vain?"

Springsteen has written several elegies before. "Terry's Song" was tacked on as a coda to his 2007 album *Magic*. Terry Magovern was Springsteen's bodyguard and an ex–Navy SEAL who served as his longtime assistant. Another song, "The Last Carnival" from *Working on a Dream*, is Springsteen's poignant tribute to friendship, honoring Danny Federici, his great pal and E Street bandmate who died of melanoma in 2008. In both a riffing on and a revisiting of "Wild Billy's Circus Story" from his second album, *The Wild, the Innocent & the E Street Shuffle*, Springsteen replaces the excitement of the fire-eaters, sword swallowers, human cannonballs, and flying Zambinis with more muted and melancholy images: tents are taken down and the fairgrounds are empty as the carnival leaves town one last time.

On February 1, 2023, Springsteen and the E Street Band launched their first tour since the pandemic—and their first concert in six years—at the Amalie Arena in Tampa, Florida.[1] The concert featured an eighteen-piece band. In addition to the E Street Band members and other regulars, it also included four backup singers, a five-piece horn section, and a percussionist. While Springsteen featured his usual rousing and crowd-pleasing songs (from "No Surrender" to "Rosalita"), he also intentionally emphasized selections about death and mortality such as the Commodores' 1985 hit "Nightshift," a tribute to Marvin Gaye and Jackie Wilson, both of whom died the previous year, from his 2022 album of soul covers, *Only the Strong Survive*. In an insightful Twitter post, former *Chicago Tribune* music critic Greg Kot, commenting on the show at Wrigley Field, observed that older songs were juxtaposed with newer material, creating a new context for both. He heard classic songs in a new way. Even "Thunder Road" seemed "transformed revealing a fresh perspective on mortality and how to proceed in the face of it." Midway through the Tampa show, Springsteen stood alone with

his acoustic guitar and talked about his first band, the Castiles, and the death in 2018 of his childhood friend and bandmate George Theiss. During the show he also acknowledged other people now gone: Danny Federici, Clarence Clemons. Theiss's death was the inspiration for Springsteen's "Last Man Standing" from *Letter to You*. "His passing would leave me as the last living member of my first band," he told the audience. The song, he added, is "about the job we choose, the friends we choose, the passion we followed as children. At 15, it's all tomorrows. At 73, a lot of yesterdays. A lot of goodbyes. That's why you gotta make the most of right now." Pink Floyd in "Eclipse" on *Dark Side of the Moon* put it another way: "All that is now and all that is gone."

His reflective mood does not mean that he has necessarily stopped caring or commenting on politics entirely, as some have suggested. He hasn't lost his political edge. During his stint on Broadway, he made a cryptic slight at Trump. More specifically, on an episode of his Sirius XM E Street Radio show in October 2020, he said, "A good portion of our fine country, to my eye, has been thoroughly hypnotized, brainwashed by a con man from Queens. You mix in some jingoism, some phony patriotism, fear of a Black planet, vanity, narcissism, paranoia, conspiracy theories and a portion of our nation undergoing mass delusions and teetering on violence, and you're left with the greatest threat to democracy in my lifetime. How did he do it?" he asked.[2]

Clouds

Coda

Far beyond Today

Springsteen sings about topics usually outside the milieu of popular music. He writes about the real world: a son's troubled relationship with his father, the psychological toll of long-term unemployment, the devastating effects of the economic recessions, and, more recently, the emotional repercussions of losing loved ones. In the past decade or so memoirs have been written about how Springsteen's music has changed lives by opening up the idea of possibility; by suggesting the way things could be. His music speaks directly to the individual and is so particular in its details that it transcends specificity to become universal so that whether an unemployed twentysomething Pakistani from England (*Greetings from Bury Park* by Sarfraz Manzoor) or a Canadian writer in Vancouver (*Walk Like a Man* by Robert Wiersema), the universal message is clear and heard.

Springsteen believes that we are all in this together, that we all have a shared purpose and a sense of community, that we are here to help each other in some way, that we are here to take care of each other before and after and far beyond today. He has often talked about his search for identity, for personal recognition, and the need for communion. "What do we owe each other?" Springsteen asks in *Renegades*.

The ties that bind, indeed.

But the ties that bind are tattered. Columnist Nicholas Kristof blames the social malady confronting America today, and the

overall decline of civility, on the lack of blue-collar jobs, the proliferation of hard drugs, the unraveling of the social fabric "and the collapse of churches, clubs and other local institutions." Political scientist Robert D. Putnam wrote about some of these issues years ago in his best-selling *Bowling Alone* and came much to the same conclusion. Others cite income inequality, rampant homelessness, public disorder, and street violence. Adrienne LaFrance in the *Atlantic* uses the word "decivilization" to describe a situation where "ordinary people fail to find common ground with one another and lose faith in institutions and elected leaders."

Meanwhile, Springsteen has spent his career writing about these very issues in his own way. Artists like Springsteen encourage feelings of solidarity in their audience, creating a sense of community even while performing in huge stadiums. Dance critic Brian Seibert calls it "mass intimacy"—Taylor Swift is a master of this form of communication as is Springsteen himself. Anthropologists Roseann Liu and Savannah Shange use the term "thick solidarity." To Liu, it refers to the "radical belief in the inherent value of each other's lives despite never being able to fully understand or fully share in the experience of those lives."

One way to measure the effect singers have on other singers is if other singers are performing their songs. Performers have been recording Springsteen songs for decades. One album in particular continues to resonate in twenty-first-century America: *Nebraska*.

"I think *Nebraska* was the big bang of the indie rock that was about making shit alone in your bedroom," Matt Berninger, lead singer of the National, told author Warren Zanes. *Nebraska* has spawned two biographies (David Burke's *Heart of Darkness* and Zanes's *Deliver Me from Nowhere*), a collection of short stories (Tennessee Jones's *Deliver Me from Nowhere*), at least two plays (Tympanic Theatre Company's *Deliver Us from Nowhere: Tales from Nebraska* and Bruised Orange Theater Company's *The Nebraska Project*, both produced in Chicago), a movie (Sean Penn's *The Indian Runner*, inspired by *Nebraska*'s "Highway Patrolman"), and a tribute album (*Badlands: A Tribute to Bruce Springsteen's*

Nebraska). In late 2022, two singer-songwriters—Aoife O'Donovan and Ryan Adams—released their respective versions of *Nebraska* as online downloads. O'Donovan recorded the songs live at her Brooklyn home. Springsteen himself has called *Nebraska* his masterpiece.

Songwriting, like poetry, is a series of images. Dylan calls them snapshots that make up a larger whole. Often the most memorable "snapshots" are of everyday dreams by everyday people. Some of Springsteen's best songs are about ordinary people doing ordinary things, working at ordinary jobs or, more likely, trying to escape from them altogether. He sings the workingman blues even though he has never been an actual workingman himself. He has worked *for* himself, not for anyone else. People have worked *for* him. He was the boss before he became the Boss.

He is a songwriter, and ultimately it is as a songwriter that his songs are and will be his legacy. Years from now cultural historians will study his output to see how a slice of life in America was lived in the mid-twentieth century and early twenty-first. His work also lives on in the interpretations of other songwriters from Brian Fallon of the Gaslight Anthem to Brandon Flowers of the Killers. In 2012, country singer Eric Church had a crossover hit with "Springsteen" (Does any other singer have a song named after them?[1]), about how music can evoke specific memories ("Like a soundtrack to a July Saturday night"). Other musicians influenced by him include Pearl Jam, Justin Vernon, Steve Earle, Melissa Etheridge, the National, John Mellencamp, Patty Griffin, Rosanne Cash, Emmylou Harris, Lucinda Williams, Frank Turner, and Sleater-Kinney, among others. In 2012, Lana Del Rey name-checked him in her song, "American" on her *Paradise* album. And even sociologists seem to have been influenced by or at least riff on his work. In 2000, Robert Lee Maril published *Waltzing with the Ghost of Tom Joad: Poverty, Myth, and Low-Wage Labor in Oklahoma*.

He continues to release new work—*Only the Strong Survive*, a cover album of soul songs in 2022—and continues to tour. Whether performing on Broadway or in stadiums, he remains the master of the live show. The stage is where he most fully comes alive.

Throughout his career, Springsteen has written about the full breadth of the human experience from wistful memories of a summer's end ("4th of July, Asbury Park [Sandy]") to the arrival of autumn as time slowly slips away ("Life Itself"). Everything is as fleeting as the passing of the seasons. We try to capture the moments that we savor and hold onto them as long as we can, whether a meal, a song, or a life, especially a life. But that is the price of being human. Nothing lasts forever and all love, even the greatest, ultimately and inevitably ends in heartbreak. And then the cycle starts anew and, as Springsteen says in "Surprise, Surprise," we all begin "the start of a brand new day."

As mentioned earlier, Springsteen is known for his empathy. He told Melissa Block of NPR that the act of making music is similar to "putting on somebody else's clothes. Part of doing your job well is being able to slip into somebody's else's shoes and to find out what you have in common with them . . ." He combines the vision of Thomas Hart Benton, the spirit of John Steinbeck, and the soul of Pete Seeger. I referred earlier to his "servant" leadership. Part of this role is his ability to write songs from the perspective of other people—people of a different gender, class, and race—who have ostensibly nothing in common with him. By fair means and foul, he writes songs of the disposed, the disenfranchised, the souls of the various departed. He writes about himself, but like a natural storyteller whose world is his topic, more often he writes about others and our shared experiences. Or as singer-songwriter Joe Henry asked in "Pass Through Me Now" on his timeless and out of time 2023 album *All the Eye Can See*, "How did I think this story just my own?"

Springsteen's earlier songs may have been inspired by his life in New Jersey and along the Jersey Shore, but for millions of fans around the world the picaresque stories and ragamuffin characters were about them. Whether intentional or not, the songs—many of them at least—were about you, were about us. It seemed as if he was speaking directly to us. His songs will last as long as other people can see themselves in his songs.

Afterword

ANDRE DUBUS III

I'm ten years younger than Bruce Springsteen, and his music has moved through my blood since I was sixteen and first heard "Meeting Across the River," this plaintive, stripped-down tale of a kid from the back streets looking for just one score so his girl will know that "he wasn't just talkin'." I was that street kid myself, living in a half-dead mill town on a polluted river, my single mother trying to raise four unhappy kids alone, my best friend a pickpocket and shoplifter whose mother was drinking herself to death, a boy who would be dead at twenty-five.

Can you lend me a few bucks, can you give me a ride?

When I first listened to the songs on *Born to Run*, I was listening to the sounds of my own neighborhood—the clank and roll of shopping cart wheels the welfare mothers would push to the grocery store on days their checks came in, the roar of the Harley-Davidsons speeding up Seventh past the projects where we'd go to get drunk and high, chained Dobermans barking, kids crying, men and women yelling at each other on the other side of thin walls or cracked windows held together with duct tape, the wail of a police siren at two in the morning, the gunning engine of an SS Chevelle speeding down Main Street with the headlights off, pretty girls in halter tops and hip-hugger jeans huddled together smoking Kools,

their cackling laughter already like their mothers who sat on stoops drinking tall boys and yelling at their younger kids to get inside the house, the wordlessness of men leaving for work and coming home at night, the blare of TVs, the iron clank of barbells in my basement, my burning eyes and my own heavy breathing and my fervent wish to leave this "town full of losers, and I'm pulling out of here to win."

I did not actually believe that I would win at anything. Nor did I believe that my town was full of losers. I just wanted to feel more alive and less alone and stop being so afraid all of the time: listening to Bruce Springsteen's music helped do that for me.

When *Darkness on the Edge of Town* came out, I boarded a Greyhound bus and fled those days when one more landlord stood at the door asking for the rent check my mother just did not have. I fled streets where men hit women, where one neighborhood was filled with the poor and another, up past the reservoir, was filled with doctors and lawyers and the owners of the factories we kids broke into for something to do.

> *Some guys come home from work and wash up, others go racing in the street.*

I raced away to Austin, Texas, where I studied history and political science and economics, where I began to see clearly the roots of injustice and the heavy weight of class in America, where I listened to *The River* and was carried back to the river valley north of Boston where I was raised. In that title song, Springsteen writes about being raised to do what your father did, though many of our dads drove away when we were young, and the ones who stayed worked in the trades or over at the Western Electric plant. As my friends got closer to graduation, all they talked about was which shifts they wanted at Western.

When *Nebraska* came out in the early eighties I was in my early twenties and discovered creative writing, and it saved my life. It made me a witness and a listener, and I began to write about the

people I came from—men doing time, women trying to leave men who didn't know how to love them, people making mistakes from which they never seem to recover. Before sitting down to write any of these stories, I would often listen to the raw grit of *Nebraska*. Inside Springsteen's spare and deeply evocative lyrics was the howling expression of all I'd known, especially the isolation caused by poverty.

> *Now mister, the day the lottery I win, I ain't ever gonna ride in no used car again.*

Every generation needs its beacons that come before them, beams of light that pulse through the fog of what it means to be human. And perhaps what draws me and millions of others to Springsteen's work is that he has never tried to deny that this often blinding fog exists, that so much of our lives are lived in mystery marked by suffering but also buoyed with daily moments of loving illumination. In his 1992 song "Living Proof," Springsteen describes living in a hard world but also seeing his infant son in his mother's arms as "a little piece of the Lord's undying light."

This may be Springsteen's greatest gift to us, his refusal to look away from the world's injustices, most notably the powerful lording over the powerless, yet he still celebrates his daily faith that there is grace everywhere if you simply allow yourself to see it.

In this wonderfully insightful and important exploration of one of our country's most essential artists, June Skinner Sawyers has captured all of this and more. She plumbs here the intersecting threads of Springsteen's lapsed Catholic faith yet lingering sacred vision, his fine eye and ear for the ravages of a class system in a supposed democracy, and his innate call to political action without his art ever becoming didactic or polemical. Sawyers also rightly points out that as Bruce Springsteen has gotten older, along with so many of his admirers, including this former mill town boy who first heard *Born to Run* nearly fifty years ago, Springsteen's songs are "bathed in the mystery of faith, and doubt. As he has aged, he has become

less sure of certainty. To him, doubt is not a sign of weakness but rather an acknowledgment of maturity."

This is an act of courageous spiritual clarity that may just ignite us to rise up and fight those injustices, each in our own way, be it through active political engagement, artistic expression, or simply allowing ourselves to step faithfully into the deep mystery of living that is our universally shared experience, so why not look out for each other? Why not take care of our own?

Acknowledgments

This book wouldn't exist without Ivan R. Dee. *We Take Care of Our Own* started life in 2014 as a digital only e-single with a different title for Ivan's Now and Then Reader. Prior to his digital enterprise, Ivan published exquisite books under his own name. It was an honor that he asked me to write for him. Since then, I have updated and revised it—gave it more bulk—moved things around a bit, and added notes, an index, and a dozen or so original photographs taken either by myself or by Theresa Albini, who took one glorious image of the Boss at the Walter Kerr Theatre during his Springsteen on Broadway run. I was there too, but Theresa managed to get the money shot. I also owe my deepest gratitude and appreciation to Theresa for her invaluable input, support, and good humor.

The inspiration behind the project came from several sources, including Tom Piazza's small gem of a book about bluegrass iconoclast Jimmy Martin, *True Adventures with the King of Bluegrass*, Alec Wilkinson's *The Protest Singer*, and Patti Smith's best-selling *M Train* and her very lovely *Woolgathering*. Similarly, Thomas Lynch's *The Undertaking: Life Studies from the Dismal Trade*—sad and life-affirming in contradictory ways—was also influential, especially in his treatment of photographs. Either way, *We Take Care of Our Own* is intended to be read in one sitting, a small stocking stuffer of a book.

Speaking of photographs, my inspiration comes from the black-and-white cinematography of such masters as Gregg Toland (Orson Welles's *Citizen Kane* and John Ford's *The Grapes of Wrath*), George

Barnes (Welles's *Force of Evil*), and the Coen Brothers (*The Man Who Wasn't There*) as well as the work of numerous female photographers, including Margaret Fay Shaw, Berenice Abbott, Dorothea Lange, Margaret Bourke-White, and Vivian Maier.

This is my fifth book about Springsteen. His songs—old and new, past and present—lead me to think thoughts and more thoughts. *We Take Care of Our Own* has a specific angle: looking at Springsteen's life and work—his art—through the triple lens of faith, class, and politics and written from the perspective of an immigrant—albeit one who has lived in the United States for a long time and yet who still remains an outsider. This attitude, I think, lends a distinctive point of view without, say, the emotional and historical baggage that might be attached to a native-born American.

Thank you to Springsteen scholars Jim Cullen and Irwin Streight for their feedback, encouragement, and friendship over the years. Thank you to Jim, in particular, for suggesting the subtitle. In the poem "Riding Down Kingsley" that appears in these pages, Irwin was the one who accompanied me to Asbury Park, as we drove along Ocean Avenue, the wide Atlantic peering outside our car window. Bill Savage's class at the Newberry Library on *The Grapes of Wrath* helped me see John Steinbeck with a new perspective and to appreciate better his influence on Springsteen. Special thanks go to Peter Mickulas, my editor, for shepherding another Springsteen book of mine into existence.

Finally, I can't thank Andre Dubus III enough for his thoughtful and altogether wonderful Afterword. I have long admired his work and the work of his father as well. When I read his brutal, poignant, and glorious memoir *Townie* and saw that it contained a "Born to Run" epigraph, I knew I had to ask if he would consider writing a few words about this book, not knowing what to expect. Much to my great surprise—and honor and pleasure—he said yes.

Notes

INTRODUCTION

1. During his unsuccessful 2012 presidential run, Republican nominee Mitt Romney famously and disastrously declared at a fundraising event that 47 percent of the U.S. populace was made up of people who believe they are "victims" and are "dependent on government" largesse, "so my job," he concluded, "is not to worry about those people." According to Federal Reserve data, as of 2021, the top 1 percent of households in the United States held 32.3 percent of the country's wealth.

CHAPTER I WORKINGMAN

1. And he didn't even have his first drink—a shot of Jose Cuervo tequila at a club in Manasquan—until he was twenty-two. Decades later, in November 2021, R. L. Hayes, a National Park Service ranger, arrested Springsteen after he was stopped on his Triumph motorcycle near Sandy Hook Lighthouse in New Jersey. In February 2022, the charges of drunken driving and reckless driving were dismissed. He pleaded guilty to the least serious of the charges—drinking alcohol in an area where it was barred—and paid the fine of $540. Springsteen had consumed two tequila shots from a bottle of Patrón during a twenty-minute time span. Significantly, prior to the arrest Springsteen had no prior DWIs, parking tickets, or traffic tickets in the entire state. The incident occurred several days after Springsteen appeared in a two-minute Jeep ad promoting national unity, titled "The Middle," that ran during the Super Bowl. Filmed over a five-day period at various sites in Nebraska, Colorado, and Nebraska, the ad was pulled immediately.

2. Springsteen told Warren Zanes that the Colts Neck rental was "kind of a funky place where I'd be staying for a year or so after I came in off

the road." Among its most distinctive features was wall-to-wall orange shag carpeting.

3. According to Alissa Quart in *Bootstrapped*, Kentucky politician Henry Clay popularized the phrase "self-made man" in 1832. As Quart also points out, during Dwight D. Eisenhower's administration, Americans paid a top tax rate of 91 percent.

CHAPTER 2 A SENSE OF PLACE

1. A devilish Tillie appears on the label of Shmaltz Brewing's Coney Island Lager, his red lips revealing a set of pearly whites, his eyes wide open, his neatly parted hair flaring out at the sides into horns.

2. In 2020, the United States ranked twenty-seventh on a list of eighty-two countries that appear on the Global Social Mobility Index, beneath Lithuania and South Korea. Denmark ranked first, with the Ivory Coast last.

CHAPTER 3 CHAPTER AND VERSE

1. Are we meant to take this oft-reported tale literally? Or is it apocryphal?

CHAPTER 5 THE POPULIST IMPERATIVE

1. Other Steinbeck Award recipients have included José Andrés, John Sayles, Arthur Miller, Jackson Browne, Studs Terkel, Joan Baez, Sean Penn, Garrison Keillor, Dolores Huerta, Michael Moore, Rachel Maddow, John Mellencamp, Ken Burns, Khaled Hosseini, Ruby Bridges, Francisco Jiménez, Bob Woodruff, Bill McKibben, and Mumford & Sons. Steinbeck was a Roosevelt New Deal Democrat.

Country music has its own version of the Steinbeck Award. Established in 2016, the Merle Haggard Spirit Award is given to singer-songwriters who continue the legacy of country iconoclast Merle Haggard. In 2021, the blue-collar country superstar Toby Keith was given the award (past winners have included the Charlie Daniels Band, Dierks Bentley, Eric Church, and Miranda Lambert).

CHAPTER 6 HOPE AND DREAMS

1. The 1887 hymn "Leaning on the Everlasting Arms" has appeared in many movies, but few renditions were as moving or sublime as Iris DeMent's interpretation in the Coen Brothers' *True Grit*.

2. The Universal Declaration of Human Rights (UDHR) was adopted by the United Nations General Assembly on December 10, 1948, in Paris. It is considered the first global expression of rights that belong to all human beings. The authors of the declaration hailed from Canada, France, China, Lebanon, and the United States and included such prominent figures as Eleanor Roosevelt. Nearly fifty countries, including the United States, voted in favor of the declaration. In many countries, health care is viewed as a human right. As far back as the 1940s, both the World Health Organization (WHO) and the United Nations declared health care one of the fundamental human rights.

3. Approximately 40,000 to 45,000 people in America die from gun violence each year. "No other country has this problem," says writer Paul Auster. Victims of mass shootings make up about 1 percent of overall gun deaths in the United States, according to the advocacy group Everytown for Gun Safety. Indeed, it appears that no place is immune from gun violence—schools, shopping malls, movie theaters, big box stores, work sites, churches and synagogues, grocery stores, concerts, even Fourth of July and Super Bowl parades. "One of the cultural problems is that we are losing the ability to be in community with one another," said Jason Kander, the former Missouri secretary of state (and nephew of *Cabaret* composer John Kander), to John Branch of the *New York Times*.

CHAPTER 8 AN ABSENCE OF THINGS

1. Springsteen's theatrical equivalent might be Samuel D. Hunter, whose plays often center on working-class laborers in small-town and rural Idaho. (Hunter's first job was at a Walmart in Moscow, Idaho.) *New York Times* theater critic Jesse Green refers to Hunter as "the reigning bard of American economic dead-endism."

CHAPTER 9 JERSEY COWBOY

1. Glen Campbell called the numerous Jimmy Webb songs that he so memorably recorded as "hurt soul." See Jones, *Wichita Lineman*.

2. In recent years, though, artists ranging from Paul Simon to Natalie Merchant have revisited old songs, coming up with new arrangements. In 2023, U2 released *Songs of Surrender*, consisting of forty of their songs with mostly acoustic or piano-based arrangements. Some songs even contained new or updated lyrics. Perhaps most famously, Taylor Swift has been rerecording some of her classic albums (such as *1989, Fearless, Red,* and *Speak Now*) as "Taylor's Version."

3. Springsteen has another thing in common with Seeger. His song "The Big Muddy" from the underrated 1992 album *Lucky Town* uses a line, "waist deep in the big muddy," from Seeger's 1967 antiwar song "Waist Deep in the Big Muddy." Everyone in Springsteen's "Big Muddy" in one way or another gets their hands dirty while Seeger's politically charged original is an angry cry against military incompetence. "We're waist deep in the big muddy," Seeger sings, "and the big fool says to push on." Conventional wisdom at the time concluded that Seeger was writing about the Vietnam War and the "big fool" of the lyric was Lyndon Johnson. "It was an allegory," Seeger told Alec Wilkinson, "and a very obvious one." Conservative critics condemned Seeger's song as being anti-American in the same way that police organizations complained that Springsteen's "American Skin" was anti-police. From Steinbeck to Seeger to Springsteen, the Seeger favorite and country and bluegrass standard, and early minstrel hit, "Ol' Dan Tucker" appears on Springsteen's *Seeger Sessions*, but it also shows up in the pages of *The Grapes of Wrath*.

4. Larry Weiss, a Jewish songwriter and musician who grew up in Queens, also wrote the American Breed's 1968 hit "Bend Me, Shape Me."

5. The Buffalo Bills football team is named in Cody's honor. In addition to Joel McCrea, Cody has been portrayed by numerous actors, including Roy Rogers, Clayton Moore, Charlton Heston, Gordon Scott, Stephen Baldwin, Keith Carradine, and J. K. Simmons. Most famously, Paul Newman played him as a loud-mouthed and possibly demented buffoon in Robert Altman's 1976 revisionist Western *Buffalo Bill and the Indians, or Sitting Bull's History Lesson*.

CHAPTER 10 TOMORROWS AND YESTERDAYS

1. The tour began amid controversy caused by Ticketmaster's new premium, algorithm-based model and its subsequent and dramatic rise in ticket prices—sometimes as high as an astounding $6,000—and Springsteen's surprisingly nonchalant and tone deaf reaction. "I know it was unpopular with some fans," he told *Rolling Stone*. "But if there's any complaints on the way out, you can have your money back." The controversy led editor Christopher Phillips to shut down the Springsteen fanzine *Backstreets*, after more than forty years.

2. Springsteen's set list for the show was thoughtfully curated, including "Everybody Knows" by Leonard Cohen, "I Put a Spell on You" by Nina Simone, "My President Is Black" (remix) by Jay-Z, "Liar, Liar" by the Castaways, "Get Up, Get into It, Get Involved" by James Brown, "America

the Beautiful" by Pete Seeger, "This Land Is Your Land" by Woody Guthrie, and two of his own songs, "Death to My Hometown" and "The Promised Land." Oh, and he also included, presumably just to be provocative, a pro-Trump rap song, "Trump Is Your President," by Bryson Gray.

CODA

1. Actually two songs reference John Mellencamp: Keith Urban's "John Cougar, John Deere, John 3:16" and Jake Owen's "I Was Jack (You Were Diane)." But still.

Selected Bibliography

Alterman, Eric. *It Ain't No Sin to Be Glad You're Alive: The Promise of Bruce Springsteen*. Boston: Little, Brown, 1999.

"Andrew M. Greeley on the Catholic Imagination of Bruce Springsteen." *America*, February 6, 1988.

Auster, Paul. *Bloodbath Nation*. Photographs by Spencer Ostrander. New York: Grove Press, 2023.

Benfey, Christopher. "Buildings Come to Life." *New York Review of Books*, February 23, 2023.

Blake, Richard A. *Afterimage: The Indelible Catholic Imagination of Six American Filmmakers*. Chicago: Loyola Press, 2000.

Block, Melissa. "Springsteen Speaks: The Music of Pete Seeger." NPR, April 26, 2006.

Branch, John. "American Scenes: Game, Parade, Shooting." *New York Times*, February 18, 2024.

Brooks, David. "Can We Talk about Joe Biden?" *New York Times*, October 8, 2023.

———. "Men on the Threshold." *New York Times*, July 16, 2013.

"Bruce Springsteen: By the Book." *New York Times*, October 30, 2014.

Bruder, Jessica. *Nomadland: Surviving America in the Twenty-First Century*. New York: Norton, 2017.

Burke, David. *Heart of Darkness: Bruce Springsteen's* Nebraska. London: Cherry Red Books, 2011.

Burns, Nick. "Darkness on the Edge of Town: Bruce Springsteen and the White Working Class." *Stanford Daily*, January 18, 2017.

Carlin, Peter Ames. *Bruce*. New York: Touchstone / Simon & Schuster, 2012.

Case, Anne, and Angus Deaton. *Deaths of Despair and the Future of Capitalism*. Princeton, NJ: Princeton University Press, 2020.

Chabon, Michael. *The Mysteries of Pittsburgh*. New York: HarperPerennial, 2005.

Clark, Amy D. "Appalachian Hope and Heartbreak." *New York Times*, August 3, 2013.

Cohen, Jonathan D., and June Skinner Sawyers, eds. *Long Walk Home: Reflections on Bruce Springsteen*. New Brunswick, NJ: Rutgers University Press, 2019.

Coleman, Ray. "Interview with Bruce Springsteen." *Melody Maker*, November 15, 1975. In *Talk about a Dream: The Essential Interviews of Bruce Springsteen*. Edited by Christopher Phillips and Louis P. Masur. New York: Bloomsbury Press, 2013.

Costello, Elvis. "Interview with Bruce Springsteen." *Spectacle*, September 25, 2009, and January 27, 2010. In *Talk about a Dream: The Essential Interviews of Bruce Springsteen*. Edited by Christopher Phillips and Louis P. Masur. New York: Bloomsbury Press, 2013.

Crèvecoeur, J. Hector St. John de. *Letters from an American Farmer and Sketches of Eighteenth-Century America*. New York: Penguin, 1981. Originally published in 1782 by Davies & Davis.

Cullen, Jim. *Born in the U.S.A.: Bruce Springsteen in American Life*. 3rd ed., revised and expanded. New Brunswick, NJ: Rutgers University Press, 2024.

———. *Bridge and Tunnel Boys: Bruce Springsteen, Billy Joel, and the Metropolitan Sound of the American Century*. New Brunswick, NJ: Rutgers University Press, 2024.

Dalton, Joseph. "My Hometown." *Rolling Stone*, October 10, 1985.

Dawidoff, Nicholas. "A Friendship in Photography." *New Yorker*, October 26, 2023.

———. *In the Country of Country: A Journey to the Roots of American Music*. New York: Vintage, 1998.

Desmond, Matthew. *Evicted: Poverty and Profit in the American City*. New York: Broadway Books, 2016.

———. *Poverty, by America*. New York: Crown, 2023.

Du Mez, Kristin Kobes. *Jesus and John Wayne: How White Evangelicals Corrupted a Faith and Fractured a Nation*. New York: Liveright, 2021.

Dylan, Bob. *The Philosophy of Modern Song*. New York: Simon & Schuster, 2022.

Ehrlich, Gretel. *The Solace of Open Spaces*. New York: Penguin, 1985.

Elwood-Dieu, Kai, Jessica Piper, and Beatrice Jin, "Elections 2022: The Educational Divide that Helps Explain the Midterms," *Politico*, November 17, 2022.

Frank, Robert. *The Americans*. New York: Grove Press, 1959.

Frankel, Glenn. *The Searchers: The Making of an American Legend*. New York: Bloomsbury, 2013.

Garman, Bryan K. "The Ghost of History: Bruce Springsteen, Woody Guthrie, and the Hurt Song." *Popular Music and Society* 20, no. 2 (Summer 1996): 69–120.

Garson, Barbara. *Down the Up Escalator: How the 99% Live in the Great Recession*. New York: Doubleday, 2013.

Gauthier, Mary. *Saved by a Song: The Art and Healing Power of Songwriting*. New York: St. Martin's, 2021.

Goldberg, Michelle. "MAGA Has Devoured American Evangelicalism." *New York Times*, January 13, 2024.

Goldstein, Amy. *Janesville: An American Story*. New York: Simon & Schuster, 2017.

Gorner, Jeremy. "Darren Bailey's Uphill Candidacy for Farmers, Cops and Illinoisans Who Feel 'Pushed Aside.'" *Chicago Tribune*, October 23, 2022.

Graham, Ruth, and Charles Homans. "A New Breed of Evangelical Finds a Defender in Trump." *New York Times*, January 11, 2024.

Guterman, Jimmy. *Runaway American Dream: Listening to Bruce Springsteen*. Cambridge, MA: Da Capo Press, 2005.

Haberman, Maggie, and Shane Goldmacher. "Trump Vow of 'Retribution' Foretells a 2nd Term of Spite." *New York Times*, March 8, 2023.

Hagen, Mark. "Interview." *MOJO*, January 1999.

Jennings, Dana. *Sing Me Back Home: Love, Death, and Country Music*. New York: Faber and Faber, 2008.

Jones, Dylan. *The Wichita Lineman: Searching in the Sun for the World's Greatest Unfinished Song*. London: Faber and Faber, 2019.

Jones, Tennessee. *Deliver Me from Nowhere*. Brooklyn, NY: Soft Skull Press, 2005.

Kasakove, Sophie, and Robert Gebeloff. "The Shrinking of the Middle-Class Neighborhood." *New York Times*, July 7, 2022.

Kay, Sean. *America's Search for Security: The Triumph of Idealism and the Return of Realism*. Lanham, MD: Rowman & Littlefield, 2014.

Kot, Greg. Twitter post, August 10, 2023.

Kristof, Nicholas. "Biden's Vision about How to Heal America." *New York Times*, February 8, 2023.

Krugman, Paul. "The Populist Imperative." *New York Times*, January 24, 2014.

LaFrance, Adrienne. "The New Anarchy." *Atlantic*, April 2023.

Laing, Olivia. *The Lonely City: Adventures in the Art of Being Alone.* New York: Picador, 2016.

Liu, Roseann. *Designed to Fail: Why Racial Equity in School Funding Is So Hard to Achieve.* Chicago: University of Chicago Press, 2024.

Liu, Roseann, and Savannah Shange, "Toward Thick Solidarity: Theorizing Empathy in Social Justice Movements." *Radical History Review* 2018, no. 131, 189–198.

Loder, Kurt. "The Rolling Stone Interview: Bruce Springsteen on Born in the U.S.A." *Rolling Stone*, December 7, 1984.

Lowrey, Annie. "50 Years Later, War on Poverty Is a Mixed Bag." *New York Times*, January 4, 2014.

MacGillis, Alec. "Tim Ryan Is Fighting for the Soul of the Democratic Party." *New York Times*, October 23, 2022.

Maharidge, Dale. *F**ked at Birth: Recalibrating the American Dream for the 2020s.* Los Angeles: Unnamed Press, 2020.

———. "I Find the Homeless Hateful." *New York Times*, December 9, 1991.

———. *Journey to Nowhere: The Saga of the New Underclass.* Photography by Michael S. Williamson. Introduction by Bruce Springsteen. New York: Hyperion, 1996.

———. *Someplace Like America: Tales from the New Great Depression.* Photography by Michael S. Williamson. Updated edition with a new preface and afterword. Foreword by Bruce Springsteen. Berkeley: University of California Press, 2013.

Manzoor, Sarfraz. *Greetings from Bury Park: A Memoir.* New York: Vintage Departures, 2007.

Maril, Robert Lee. *Waltzing with the Ghost of Tom Joad: Poverty, Myth, and Low-Wage Labor in Oklahoma.* Norman, OK: University of Oklahoma Press, 2002.

Marquart, Debra. *The Horizontal World: Growing Up in the Middle of Nowhere.* New York: Counterpoint, 2006.

Marsh, Dave. *Two Hearts: The Definitive Biography, 1972–2003.* New York: Routledge, 2004.

Masur, Louis P. *Runaway Dream: Born to Run and Bruce Springsteen's American Vision.* New York: Bloomsbury, 2009.

McMurtry, Larry. *Reading Walter Benjamin at the Dairy Queen: Reflections on Sixty and Beyond.* New York: Touchstone, 2001.

Norris, Kathleen. *Dakota: A Spiritual Geography.* Boston: Mariner / Houghton Mifflin, 2001.

Obama, Barack, and Bruce Springsteen. *Renegades: Born in the USA*. New York: Crown, 2021.

Packer, George. *The Unwinding: An Inner History of the New America*. New York: Farrar, Straus & Giroux, 2013.

———. "What Does the Working Class Really Want?" *Atlantic*, January/February 2024.

Peterson, Jillian, and James Densley. *The Violence Project: How to Stop a Mass Shooting Epidemic*. New York: Harry Abrams, 2021.

Pew Research Center. "The Lost Decade of the Middle Class." August 22, 2012.

Piketty, Thomas. *Capital in the Twenty-First Century*. Cambridge, MA: Belknap, 2014.

Porter, Eduardo. "A Relentless Widening of Disparity in Wealth." *New York Times*, March 12, 2014.

Proulx, Annie, Larry McMurtry, and Diana Ossana. *Brokeback Mountain: Story to Screenplay*. New York: Scribner, 2005.

Quart, Alissa. *Bootstrapped: Leading Ourselves from the American Dream*. New York: HarperCollins, 2023.

Raban, Jonathan. *Bad Land: An American Romance*. New York: Vintage, 1997.

Rawls, John. *A Theory of Justice*. Revised ed. Cambridge, MA: Belknap/Harvard University Press, 1999. Originally published in 1971.

Remnick, David. "We Are Alive: Bruce Springsteen at Sixty-Two." *New Yorker*, July 30, 2012.

Rothman, Joshua. "The Lives of Poor White People." *New Yorker*, September 12, 2016.

Sawyers, June Skinner, ed. *Racing in the Street: The Bruce Springsteen Reader*. Foreword by Martin Scorsese. New York: Penguin, 2004.

———. *Tougher Than the Rest: 100 Best Bruce Springsteen Songs*. Foreword by Christopher Phillips. New York: Omnibus Press, 2006.

Schjeldahl. Peter. "Critic's Notebook: Between the Lines." *New Yorker*, July 8 and 15, 2013.

Seibert, Brian. "Simple, Effective Steps Produce a Memorable Performance." *New York Times*, August 10, 2023.

Semuels, Alana, and Belinda Luscombe. "Middle Class, Low Hopes: They Thought the Pandemic Might Be a Time to Catch Up Financially. But Things Are Worse Than Ever." *Time*, May 16, 2022.

Shipler, David K. *The Working Poor: Invisible in America*. New York: Alfred A. Knopf, 2004.

Smarsh, Sarah. *Heartland: A Memoir of Working Hard and Being Broke in the Richest Country on Earth*. New York: Scribner, 2019.

Smith, Patti. *M Train: A Memoir*. New York: Vintage, 2016.

Springsteen, Bruce. *Born to Run*. New York: Simon & Schuster, 2016.

———. "Chords for Change." *New York Times*, August 5, 2004.

———. *Songs*. New York: HarperCollins, 2003.

Stegner, Wallace. *Where the Bluebird Sings to the Lemonade Springs: Living and Writing in the West*. New York: Penguin, 1993.

Steinbeck, John. *The Grapes of Wrath*. Introduction and Notes by Robert Demott. New York: Penguin, 2006. Originally published 1939.

Sutcliffe, Phil. "You Talkin' to Me?" *MOJO*, January 2006.

Theisen, Gordon. *Staying Up Much Too Late: Edward Hopper's Nighthawks and the Dark Side of the American Psyche*. New York: Thomas Dunne Books/St. Martin's Press, 2006.

Thompson, Derek. "A World without Work." *Atlantic*, July/August 2015.

Tully, Tracey. "Not the First Rodeo for a New Jersey Town." *New York Times*, August 21, 2022.

Vance, J. D. *Hillbilly Elegy: A Memoir of Family and Culture in Crisis*. New York: Harper, 2016.

Wiersema, Robert J. *Walk Like a Man: Coming of Age with the Music of Bruce Springsteen*. Vancouver: Greystone Books, 2011.

Wilkinson, Alec. *The Protest Singer: An Intimate Portrait of Pete Seeger*. New York: Knopf, 2009.

———. "The Protest Singer: Pete Seeger and American Folk Music." *New Yorker*, April 17, 2006.

Willman, Chris. *Rednecks & Bluenecks: The Politics of Country Music*. New York: New Press, 2005.

Wolff, Daniel. *Fourth of July, Asbury Park: A History of the Promised Land*. Revised and expanded. New Brunswick, NJ: Rutgers University Press, 2022.

Wolff, Justin. *Thomas Hart Benton: A Life*. New York: Farrar, Straus & Giroux, 2012.

Zanes, Warren. *Deliver Me from Nowhere: The Making of Bruce Springsteen's Nebraska*. New York: Crown, 2023.

Zimny, Thom, director. *The Promise: The Making of Darkness on the Edge of Town*. Sony Legacy, 2010. Documentary, 1 hr. 25 min.

Index

"Adam Raised a Cain" (song), 41–42
Adams, Amy, 75–76
Adams, Ansel, 102
Adams, Ryan, 119
afterimage, 53
Agee, James, 16, 18
Age of Grievance, 74
Alabama, 16
Alice Doesn't Live Here Anymore (film), 88
All the Eye Can See (Henry), 120
Altman, Robert, 130n5
"American" (song), 119
Americana, 95–96
American Breed, 130n4
American Dream, 3, 12, 70–71, 73, 83, 111
American Gothic (Wood), 86–87
Americans, The (Frank), 89
"American Skin (41 Shots)" (song), 62, 130n3
American West, 93, 98, 104–5; freedom, 106; Great Western Myth, 92; isolation of, 110; loneliness, 106, 110; mobility, 103; myth of, 109; as Promised Land, 97; reign of cowboy, as short-lived, 108; rootlessness, 103; selfishness, 106; self-reliance, 102; Western Code, 102–3
Amnesty International, 66
Anderson, Sherwood, 64–65
Anthony, Oliver, 17
Appel, Mike, 8
Aquinas, Thomas, 50
Arabella (ship), 43
Argentina, 31, 66
Aristotle, 50
Arizona, 27
Art Institute of Chicago, 86
Arts of the West (Benton), 86
Asbury, Francis, 26
Asbury Park (New Jersey), 7, 54; as music mecca, 27–28; Palace Amusements, 23; as Promised Land, 21, 23, 26; as religious community, 26; Tillie, as unofficial mascot, 21
"Atlantic City" (song), 99
Augustine of Hippo, 50
Auster, Paul, 129n3
Australia, 31
Avedon, Richard, 92

"Backstreets" (song), 91
"Badlands" (song), 9
Baez, Joan, 67
Bailey, Darren, 77
Baldwin, Stephen, 130n5
"Ballad of Jesse James" (song), 99
Baron, Art, 99
Beach Boys, 44
Beatles, 21
"Before the Deluge" (song), 44
"Bend Me, Shape Me" (song), 130n4
Benfey, Christopher, 88
Bentham, Jeremy, 56
Benton, Thomas Hart, 85–86, 120
Bernardin, Joseph, 50
Berninger, Matt, 118
Biden, Joe, 57, 81
Biel, Steven, 87
"Big Muddy, The" (song), 130n3
Billy the Kid, 104–5
"Black Cowboys" (song), 41
"Black Nights in Babylon" (song), 37–38
Blake, Richard: afterimage, 53
"Blinded by the Light" (song), 99
Block, Melissa, 120
"Blowin' in the Wind" (song), 67
Boggs, Dock, 85–86
Boomtown (Benton), 86
"Born in the USA" (song), 29, 62
Born in the USA (Springsteen), 62, 66–67
Born on the Fourth of July (film), 65
Born on the Fourth of July (Kovic), 65
"Born to Run" (song), 8, 23, 29
Born to Run (Springsteen album), 8, 66–67, 96, 121, 123; as Catholic album, 39; as spiritual work, 8; as transitional, 9
Born to Run (Springsteen memoir), 15–16, 24–25, 28, 30, 54, 107
Bradley, James A., 26–27
Bragg, Billy, 16, 97
Branch, John, 129n3
Brando, Marlon, 37
Brave Cowboy Bill (Kathryn and Bryon Jackson), 98
Brazil, 66
Breakfast in America (Supertramp), 88
Britain, 111
Brokeback Mountain (film), 92, 108
Brooks, David, 11–12, 78
Brown, James, 6
Brown, Sherrod, 80–81
Browne, Jackson, 44, 63
Bruce Springsteen and the E Street Band: Live in New York City (Springsteen), 62
Bruce Springsteen Band, 99
Bruce Springsteen with the Sessions Band: Live in Dublin (Springsteen), 99
Bruder, Jessica, 31, 93
Buffalo Bill (film), 111
Buffalo Bill and the Indians, or Sitting Bull's History Lesson (film), 130n5
Buffalo Bills, 130n5
Bush, George H. W., 57, 67
Bush, George W., 1–2, 57, 61–62, 67, 108
Butch Cassidy and the Sundance Kid, 104–5

Butler, Jerry, 2
"By the Time I Get to Phoenix" (song), 106

Cain, James M., 64–65, 89
Calamity Jane, 111
California, 101; as New Jerusalem, 102; as Promised Land, 43–44, 102; Proposition 209, 67–68
"Calvin Jones & the 13th Apostle" (song), 37–38
Campbell, Glen, 104, 106, 110–11; "hurt soul," 129n1
Cantwell, Robert, 71
capitalism, 69; "throw away culture," 51; as selfish, 52
Carlin, Peter Ames, 6
Carradine, Keith, 130n5
Carter Family, 33
Carver, Raymond, 38
Case, Ann, 70
Cash, Johnny, 97
Cash, Rosanne, 119
Castiles, 114–15
Catholic Campaign for Human Development, 50
Catholic Church, 51; Catholic social teaching (CST), 50; Developing Communities Project, 50
Catholic imagination: sacramentality, notion of, 53
Catholicism: social justice, 55
Catholic social teaching (CST), 49, 68; dignity of work, 52; origins of, 50; principles of, 51–52
Catholic Worker Movement (CWM), 52–53
"Cautious Man" (song), 63
"C. C. Rider" (song), 64
Chabon, Michael, 39
Chapman, Tracy, 16–17, 66
Chapter and Verse (Springsteen), 99
"Chasin' Wild Horses" (song), 108
Cheever, John, 64–65
Chicago (Illinois), 50
"Chimes of Freedom" (song), 67
China, 31, 76
"Chords for Change" (Springsteen), 68
Christianity, 52
Christian socialism, 52
Christic Institute, 63
Church, Eric, 119
City of God (Augustine), 50
Clark, Amy D., 69
Clash, 16, 97
class, 82; classism, 81; country music, 97
Clay, Henry: "self-made man," 128n3
Clemons, Clarence, 115
Clinton, Bill, 57
Close, Glenn, 75–76
Clyde Beatty/Cole Brothers circus, 111
Cody, Buffalo Bill, 130n5; Wild West Show, 111
Cohen, Leonard, 1
Coleman, Ray, 91
Colts Neck (New Jersey), 10, 18, 107, 127–28n2
Columbia Records, 9, 98–99
Combs, Luke, 16–17
Commodores, 114
common good, 49–50

Coney Island, 111; Steeplechase Park, 23
Costello, Elvis, 36
Costner, Kevin, 88, 108
country music, 6, 10, 71, 78, 86, 95–96, 128n1; class, subtext of, 97; stereotypical themes of, 97; as white man's blues, 97
Country Music Foundation, 86
Country Music Hall of Fame and Museum, 86
"Courtesy of the Red, White and Blue" (song), 78–79
COVID-19 pandemic, 11–12, 59, 81, 114
"Cowboy Boots and a Bottle of Jack" (Sawyers), 105
"Cowboys of the Sea" (song), 98
Crane, Stephen, 21, 27
Creedence Clearwater Revival, 64
Crèvecoeur, J. Hector St. John de, 106
Crowell, Rodney, 78
Cruise, Tom, 65

Dakota: A Spiritual Geography (Norris), 83, 109
Dalton, Joseph, 30
"Darkness on the Edge of Town" (song), 9
Darkness on the Edge of Town (Springsteen), 2, 10, 16, 49, 59, 66–67, 89–91, 122; as self-revelatory, 9; as turning point, 8
Dark Side of the Moon (Pink Floyd), 115
Dawidoff, Nicholas, 67–68, 90, 96
Day, Dorothy, 52
"deaths of despair," 70

"Death to My Hometown" (song), 2, 37, 51, 61–62
Deaton, Angus, 70
deindustrialization, 75
Del Ray, Lana, 119
DeMent, Iris, 16, 128n1
Democratic Republic of the Congo, 31
Democrats, 5, 31, 80–81; New Deal Democrats, 78; Reagan Democrats, 77; southern Democrats, 78
Densley, James, 70
Departure of the Joads (Benton), 86
Desmond, Matthew, 13, 16, 31, 74
"Devils & Dust" (song), 61
Devils & Dust (Springsteen), 33, 37, 71, 99, 104
"Devil with a Blue Dress On" (song), 64
Diallo, Amadou, 62
DiGrazia, Eugene, 90
DiMucci, Dion, 36–37
diners, 88–89
Dixie Chicks, 68
Doig, Ivan, 110
Dreher, Rod, 77
Dust Bowl Ballads (Guthrie), 87
Dylan, Bob, 1, 16, 37, 41, 67, 113, 119

Earle, Steve, 16, 71, 97, 119
East of Eden (film), 41–42
East of Eden (Steinbeck), 41–42
Eastwood, Clint, 88, 108
"Easy Money" (song), 2, 51, 61–62
"Eclipse" (song), 115
economic inequality, 52
economic segregation, 12–13

Ed Sullivan Show, The (television show), 36, 97
Edwards, Ethan (character), 62–63, 91, 93
Edwards, John, 68
Ehrenreich, Barbara, 16, 49
Ehrlich, Gretel, 107
E Street Band, 23, 47, 62, 64, 66–67, 107, 114
Etheridge, Melissa, 119
Europe: social liberalism, 52
Evangelii Gaudium ("The Joy of the Gospel"): critics of, 51
Evans, Walker, 16, 18, 90
Everytown for Gun Safety, 129n3
Evicted (Desmond), 74
"Eyes of Portland, The" (song), 71

"Factory" (song), 9
Fallon, Brian, 119
farm crisis, 82–83
"Fast Car" (song), 16–17
Federici, Danny, 54–55, 114–15
Fender, Sam, 16
Fetterman, John, 80–81
Florida, 27
Flowers, Brandon, 119
Ford, John, 62–63, 86–87, 91, 99
Foster, Stephen, 58
"4th of July, Asbury Park (Sandy)" (song), 21, 23, 120
Francis, Pope, 50–51, 55
Frank, Robert, 89, 90
Frankie and Johnny (Benton), 86
Freehold (New Jersey), 3, 7, 30, 34–35, 51, 65, 69–70, 76; riots in, 27; "Texas," nickname of, 95; Springsteens in, 29

French, David, 73
Friedman, Milton, 56
"Further On (Up the Road)" (song), 99

Gabriel, Peter, 66
"Galveston" (song), 106
"Galveston Bay" (song), 43
Garman, Bryan: hurt songs, 97
Garson, Barbara, 17
Gas (Hopper), 89
Gaudium et Spes ("Pastoral Constitution on the Church and the Modern World"), 50
Gaughan, Dick, 16
Gauthier, Mary, 28
"Gave It a Name" (song), 41
Gaye, Marvin, 114
Gebeloff, Robert, 12
General Motors (GM), 11, 73
"Get Up, Stand Up" (song), 67
Ghost of Tom Joad, The (Springsteen), 16, 19, 43, 58, 61, 71, 75, 104
"Ghosts" (song), 113
Giants Stadium: demolition of, 13
Gibson, Mel, 79
"Girls in Their Summer Clothes" (song), 89
globalization, 34, 75, 80
"Goin' Cali" (song), 43
Golden Rule, 49–50
Goldstein, Amy, 15
"Good Golly Miss Molly" (song), 64
"Good Man Is Hard to Find (Pittsburgh)" (song), 65
"Good Ol' Boy (Gettin' Tough)" (song), 71

Index

Gorner, Jeremy, 77
Grapes of Wrath, The (film), 86–87
Grapes of Wrath, The (Steinbeck), 58, 83, 95, 130n3; "one big soul" speech, 46; politics of charity, 47
Great Depression, 13, 16, 31, 63
Great Recession, 1–2, 11, 13–14, 16–17, 61–62
Greeley, Andrew M., 39
Green, Jesse, 129n1
Green Day, 16
Greetings from Asbury Park, N.J. (Springsteen), 7, 28, 37, 99
Greetings from Bury Park (Manzoor), 117
Grey, Zane, 102
Griffin, Patty, 119
"Growin' Up" (song), 56, 99
gun violence, 71, 129n3; mass shootings, 70
Gun Violence Archives, 70
Guterman, Jimmy, 21
Guthrie, Nora, 59
Guthrie, Woody, 49, 58–59, 64, 67, 69, 71, 87, 96
Gyllenhaal, Jake, 92

Hagen, Mark, 11, 18
Haggard, Merle, 16, 71, 78, 97
Hall, John, 63
Hammond, John, 37, 98
Harrington, Michael: Other America, 10–11
Harris, Emmylou, 96, 119
Hayden, Tom, 68
Hayek, Friedrich, 56
Hayes, R. L., 127n1
health insurance, 13
Heartland (Smarsh), 81
Hell or High Water (film), 108
Hemingway, Ernest, 89
Henry, Joe, 120
Heston, Charlton, 130n5
High Hopes (Springsteen), 61–62, 71
High Plains Drifter (film), 88
"Highway Patrolman" (song), 99
Hillbilly Elegy (film), 75–76
Hillbilly Elegy (Vance), 75–76, 81
"Hitch Hikin'" (song), 106
Hobbes, Thomas, 56
Hobson, J. A., 56
homelessness, 75
Homestead Act, 103, 109
Hopper, Edward, 85–86, 88, 90, 106, 110
Horizontal World, The (Marquart), 109
Huck and Jim (Benton), 86
Hud (McMurtry), 103
Huerta, Dolores, 68
Human Rights Now! tour, 63, 66–67
"Hungry Eyes" (song), 71
Hunter, Samuel D., 129n1
Hurricane Katrina, 14

"I Ain't Got No Home" (song), 67
"If I Should Fall Behind" (song), 99
"If I Was the Priest" (song), 37, 113–14
Illinois, 77–78
"I'll Work for Your Love" (song), 38
"I'm on Fire" (song), 82
Impressions, 46

Index

income inequality, 13
"Independence Day" (song), 10
India, 66
Indigenous peoples, 109
individualism, 46, 64, 87, 89; self-reliance, 102; teamwork, 107; as "toxic myth," 102; Western Code, 102
inequality, 75
In the American West (Avedon), 92
"Into the Fire" (song), 53
Iraq War, 61
Isbell, Jason, 16–17, 97
"It's Hard to Be a Saint in the City" (song), 37
Ivory Coast, 66
"I Was Jack (You Were Diane)" (song), 131n1

"Jack of All Trades" (song), 2, 33, 51, 61–62
Jackson, Reverend Jesse, 68
James, Frank, 86
James, Jesse, 86, 99
Janesville (Wisconsin), 11, 15
"Janey Needs a Shooter" (song), 113–14
Jennings, Dana, 97
"Jenny Takes a Ride!" (song), 64
Jersey Shore, 5, 7, 21, 25–28, 101, 120
"Jesse James" (song), 99
"Jesus Was an Only Son" (song), 33, 37, 42–43
"John Cougar, John Deere, John 3:16" (song), 131n1
"Johnny Bye-Bye" (song), 43
"Johnny 99" (song), 62, 65
John Paul II, 39

Johnson, Lyndon Baines, 130n3; Great Society programs, 56–57
John Steinbeck Award, 58, 128n1
Jones, Dylan, 106, 111
Jones, George, 71, 96
Journey to Nowhere: Saga of the New Underclass, The (Maharidge and Williamson), 75
Judaism: *tikkun olam* ("repair of the world"), 55

Kander, Jason, 129n3
Kansas, 109; farm crisis in, 82
Kant, Immanuel, 56
Karagheusian Rug Mill, 29–30
Kasakove, Sophie, 12
Keith, Toby, 78
Kennedy, David Michael, 90
Kennedy, John F., 78
Kerry, John, 63, 68
Keynes, John Maynard, 56
Kinsey, Leroy Jr., 27
Klein, Joe, 57, 64
Kot, Greg, 114
Kovic, Ron, 65–66
Kozuszek, David, 78
Kozuszek, Mary, 77
Kristof, Nicholas, 74, 117–18
Krugman, Paul, 57

LaFrance, Adrienne: decivilization, 118
Laing, Olivia, 18
Landau, Jon, 66
"Land of Hope and Dreams" (song), 45–46
Lange, Edward, 23
"Last Carnival, The" (song), 114
"Last Man Standing" (song), 115

"Last to Die" (song), 61
"Leaning on the Everlasting Arms" (song), 63, 128n1
Ledger, Heath, 92, 108
Lee, Ang, 108
Legend, John, 68
Leo XIII, 50
Letter to You (Springsteen), 2, 37, 49, 113, 115
Let Us Now Praise Famous Men (Agee and Evans), 16
Lewis, Dean, 27
liberalism, 49, 56–58
"Life Itself" (song), 120
Limbaugh, Rush, 51
"Lion's Den" (song), 41
Liu, Roseann: thick solidarity, 118
Liverpool (England), 21
"Living Proof" (song), 123
Locke, John, 56
Loder, Kurt, 7, 39
Lonesome Dove (McMurtry), 103
"Long Time Comin'" (song), 99
"Long Walk Home" (song), 88
Lordstown (Ohio), 73–75
"Lost in the Flood" (song), 37–38
Louvin Brothers, 96
Lucky Town (Springsteen), 99, 130n3
Lyons, Stephen J., 1

Maclean, Norman, 110
Magic (Springsteen), 61–62, 71, 88–89, 114
Magovern, Terry, 114
Maharidge, Dale, 18–19, 74–75, 81–82
Manasquan (New Jersey), 7
"Mancession," 11

Manifest Destiny, 43, 109
"Mansion on the Hill" (song), 70
March on Washington, 46
"Maria's Bed" (song), 41
Maril, Robert Lee, 119
Marley, Bob, 67
Marquart, Debra, 109
Marsh, Dave, 8
Martin, Trayvon, 62
"Mary's Place" (song), 56
Mayfield, Curtis, 46, 54
McClintock, Harry, 97–98
McCrea, Joel, 111, 130n5
McDormand, Frances, 92
McGovern, George, 6–7
McKeeby, Byron, 87
McMurtry, James, 71
McMurtry, Larry, 92, 102–3, 110
Mean Streets (film), 91
"Meeting Across the River" (song), 121
Mellencamp, John, 16, 68, 71, 87, 114, 119, 131n1
Meola, Eric, 89–91
Merchant, Natalie, 129n2
Merle Haggard Spirit Award, 128n1
middle class, 13, 58, 70, 80; as left behind, 12
Middletown (Ohio), 75–76
Midwest Farmer's Daughter (Price), 83
Mill, John Stuart, 56
Missouri, 86
Mitchum, Robert, 63
Mix, Tom, 108
Moby Dick (Melville), 89
"Model of Charity, A" (Winthrop), 43

Monmouth County (New Jersey), 54
Montana, 105–6
"Moonlight Motel" (song), 106
Moore, Clayton, 130n5
Moran, Thomas, 102
Morrison, Van, 8, 28
MoveOn.org, 68
"Mrs. McGrath" (song), 37
Muller, Bobby, 66
Murtagh, Kate, 88
Musicians United for Safe Energy (MUSE), 63
"My City of Ruins" (song), 54–55
"My Hometown" (song), 34, 62
Mysteries of Pittsburgh, The (Chabon), 39

Nash, Graham, 63
Nashville (Tennessee), 13
National (band), 118–19
N'Dour, Youssou, 66
"Nebraska" (song), 18, 61, 65; as cowboy song, 110
Nebraska (Springsteen), 6, 10–11, 16, 18–19, 61–63, 71, 82, 88, 91, 99, 107, 122–23; child's perspective in, 65; cover of, 90; as "cowboy" album, 110; influence of, 118–19; Reaganomics, inspiration for, 13; solitude, as theme, 89
New Jersey, 3, 10, 13, 25, 45, 54, 65, 101–2, 110, 120; horse country, 104; rodeo circuit, 106–7
new left populism, 57
Newman, Paul, 130n5
"New Timer, The" (song), 75
New York City, 62–64

Nighthawks (Hopper), 86, 88; solitude, as theme, 89
Night of the Hunter (film), 63
Nightmare Alley (film), 111
"Nightshift" (song), 114
Nomadland (film), 92–93, 108
No Nukes concert, 63–64
Norris, Kathleen, 83, 109–10
North American Free Trade Agreement (NAFTA), 76
North Dakota, 109
"No Surrender" (song), 47, 68, 114

Oakley, Annie, 111
Oates, Joyce Carol, 5
Obama, Barack, 10, 25, 29–30, 37, 50, 57, 63, 69, 79, 91, 104
"Obamacare," 13
Occupy Wall Street movement, 13, 17
Ocean County Community College, 6
Ocean Grove (New Jersey), 26
O'Connor, Flannery, 33, 64–65
O'Donovan, Aoife, 119
Ohio, 76, 80–81
O'Keeffe, Georgia, 102
Oklahoma, 110
"Ol' Dan Tucker" (song), 130n3
Only the Strong Survive (Springsteen), 119
"Open All Night" (song), 88, 99
Orbison, Roy, 8
Orpheus Descending (Mellencamp), 71
Ossana, Diana, 92
"Outlaw Pete" (song), 98
Outlaw Pete (Springsteen and Caruso), 98

Owen, Jake, 131n1
Oz, Dr. Mehmet, 80

Packer, George, 17–18, 78
Paradise (Del Ray), 119
particularism, 55
"Pass Through Me Now" (song), 120
Pearl Jam, 68, 119
Pennsylvania, 80–81
"People Get Ready" (song), 46, 54
Peterson, Jillian, 70
Phillips, Christopher, 130n1
Piketty, Thomas, 13–14, 30
"Pink Cadillac" (song), 41
Pink Floyd, 115
polarization, 31
populist imperative, 49, 57
Postman Always Rings Twice, The (film), 91
poverty, 13, 71, 74, 82–83
Powell, John Wesley, 103
Presley, Elvis, 6, 36–37, 43, 71, 90, 96–97
Price, Margo, 83
Pritzker, JB, 77
Promise, The: The Making of Darkness on the Edge of Town (documentary), 91
Promised Land, 21, 23, 26, 43, 45–46, 88, 97, 102
"Promised Land, The" (song), 9, 43–44, 68
prosperity gospel, 52
Proulx, Annie, 92
"Prove It All Night" (song), 9
Putnam, Robert D., 71, 118

Quart, Alissa, 14, 16, 102–3, 128n3

Raban, Jonathan, 102–3
"Racing in the Street" (song), 9, 43
"Rainmaker" (song), 113
Raitt, Bonnie, 63
Rauschenbusch, Walter, 52
Rawls, John, 58
Reading Walter Benjamin at the Dairy Queen (McMurtry), 103, 110
Reagan, Ronald, 10, 34, 64, 67, 108; Reagan Democrats, 77; Reaganomics, 11, 13, 75
Rednecks & Bluenecks (Willman), 78
regional depression, 74
R.E.M., 68
Remnick, David, 25, 28
Renegades (Obama and Springsteen), 10, 25, 29, 45, 91, 104, 117
Republicans, 31, 78, 81, 102
Rerum Novarum (papal encyclical), 50
Resnik, Zimel, 23
"Resurrection" (song), 37
"Rhinestone Cowby" (song), 110–11
Rich, Charlie, 96
"Rich Men North of Richmond" (song), 17
"Riding Down Kingsley" (Sawyers), 22
"Rising, The" (song), 53–55, 69
Rising, The (Springsteen), 79, 99; redemption and salvation, themes in, 53; Stations of the Cross, 54
"River, The" (song), 65
River, The (Springsteen), 10, 63–64, 66–67, 82, 122

Index

Rock and Roll Hall of Fame, 44
"Rock Me on the Water" (song), 44
"Rocky Ground" (song), 33
Rodgers, Jimmie, 96–97, 104
Rogers, Roy, 130n5
Romney, Mitt, 2, 127n1
Roosevelt, Eleanor, 129n2
Roosevelt, Franklin D., 1, 56, 78, 88; New Deal, 15, 49, 57; Second Bill of Rights, 57
Roosevelt, Theodore, 108
"Rosalita" (song), 114
Rothman, Joshua, 77
"Roulette" (song), 64
Rumson (New Jersey), 54
"Run through the Jungle" (song), 64
Russia, 31
Ryan, Paul, 15; "American Idea," 14
Ryan, Tim, 75, 80

San Jose State: Center for Steinbeck Studies, 58
Savage, Bill: "I becoming We," notion of, 46
"Save the World" (song), 17
Schjeldahl, Peter, 89
Scialfa, Patti, 101–2, 107
Scorsese, Martin, 36–37, 56, 88–89
Scott, Gordon, 130n5
Sea Bright (New Jersey), 7
Searchers, The (film), 62–63; final scene of, 91, 93
Second Vatican Council, 50
"Seeds" (song), 61
Seeger, Charles, 85–86
Seeger, Pete, 69, 85, 101, 120, 130n3

Seeger Sessions, The (Springsteen). See *We Shall Overcome: The Seeger Sessions* (Springsteen)
Seibert, Brian: mass intimacy, 118
self-made man: myth of, 14; as phrase, 128n3
self-reliance, 64, 87, 89, 102
September 11 attacks, 53–54, 79
servant leadership, 52
"Shackled and Drawn" (song), 2, 33–34, 61–62
Shange, Savannah: thick solidarity, 118
Sheridan, Taylor, 108
Shipler, David, 16
"Silver Palomino" (song), 108
Simmons, J. K., 130n5
Simon, Paul, 129n2
"Sister Theresa" (song), 37
Sitting Bull, 111
Smarsh, Sarah, 81–83
Smith, Adam: "invisible hand" philosophy, 51
Social Gospel, 33, 49, 52
social injustice, 13
social justice, 50–52, 61, 67; as brother's keeper, 55
social mobility, 31
"Somewhere North of Nashville" (song), 104
Songs (Springsteen), 9
"Songs for Orphans" (song), 113–14
Sorkin, Amy Davidson, 76
"Soul Driver" (song), 41
"Souls of the Departed" (song), 61
Sources of Country Music, The (Benton), 86
"Springsteen" (song), 119

Springsteen, Adele, 6, 36, 98
Springsteen, Alexander, 29
Springsteen, Bruce, 2, 13, 17, 24, 27, 75–77, 80, 82–83, 85–86, 101, 108, 110, 121–23, 130n3, 130–31n4; American Dream, 111; on American reality and American Dream, gap between, 3; American West, 98, 104–5, 109; as ancestor, 71; Bible, as inspiration, 41–42; Catholic Church, complicated relationship with, 35, 37–38; Catholic education of, 35–36; Catholic faith, informing artistic vision, 35, 53; Catholic imagery, 35, 37–39; Catholic imagination, 53; Catholicism of, 1, 36–37, 55–56; Catholic ritual, 56; Catholic social teaching (CST), 51–52, 68; change in writing style, 8; childhood of, 11, 30, 34, 65, 69–70, 111; class, 97; class politics, 78; communal belonging, 46; communion, need for, 55–56, 117; community, notion of, 56, 118; community of musicians, 28; continuity, importance of, 71; core themes of, 15–16; as country lyricist, 96; country music, 10, 95–97; cowboy code, 104; dignity of work, 52; diners, 88–89; disconnected, feelings of, 18; doubt, as sign of maturity, 44, 124; elegies, 114; empathy of, 120; ethos of, 14, 49; as Everyman, 55; evolution, as songwriter, 95–96; expansive vision of, 47; the Fall, 44; fan base, demographics of, 81; father, relationship with, 10, 25, 29–30; as FDR liberal, 1, 88; film noir, 63; Golden Rule, 49–50; grace, 33, 44; have versus have-nots, 71; horse riding, 107; Human Rights Now! tour, 63, 66–67; hurt songs, 97; "I becoming We," 47; invisible, feelings of, 25; Irish Catholic ancestry, 37; isolation, as theme, 91; as Jersey Cowboy, 106; Jesus songs of, 33; John Steinbeck Award, 58; as lapsed Catholic, 33, 55; legacy of, 119; liberal brand of politics, 49–50; liberalism of, 57–58; liminal moment, 90–91; love of genre films, 91; "Middle, The" Jeep ad, 127n1; mortality, 113–15; *Night of the Hunter* (film), impact on, 63; No Nukes concert, 63–64; onstage persona, 37; outlier characters of, 62; as outsider, 35, 97; patriotism of, 1; political awakening, as slow process, 7; political awareness, 5–6; political rallies, 63, 68–69; politics of charity, 47; populist imperative of, 49; Promised Land, 21, 43–45; Proposition 209, 67–68; Protestant preacher, persona of, 45; public persona, 52; radical empathy, 65; reading habits of, 64–65; redemption, 44, 46, 56; religious images, 113; as "repair man," 28, 55; as rock and roll laureate, 1; as "runaway" Catholic, 38; *Searchers, The*

(film), impact on, 62–63; self-education of, 6; servant leadership, 52, 120; Social Gospel, 52; social justice, 52, 62; as songwriter, 119; songwriting style, 10; therapy, 10; as thinking man's rock star, 6; Ticketmaster controversy, 130n1; transitional time, 9; universal brotherhood, 46; Vote for Change tour, 68; We Are One concert, 69; Woody Guthrie Prize, 59; work, and dignity, 12; work ethic of, 6; as working-class icon, 3; workingman persona of, 29

Springsteen, Douglas, 6, 10, 12, 25, 30; as "unknowable," 29

Springsteen, Jessica, 107

Springsteen, John, 29

Springsteen, Virginia, 106–7

Springsteen on Broadway, 25, 115

Starkweather, Charles, 62, 65, 110

Starr, Edwin, 66–67

Stax Records, 8

Steel Mill, 27–28

Stegner, Wallace, 102–3, 108–9

Steigelman, Leslie, 23

Steinbeck, Elaine, 58

Steinbeck, John, 46–47, 49, 58, 83, 86–87, 95, 120, 130n3

Stewart, Rod, 2

Sting, 66

"Stolen Car" (song), 63

Stone, Oliver, 65

Stone Pony, 27–28

"Straight Time" (song), 62

Street, Michael, 13

"Streets of Philadelphia" (song), 61

Strictly a One-Eyed Jack (Mellencamp), 114

St. Rose of Lima (elementary school), 35–36, 51

Strummer, Joe, 16, 97

Student Prince, 27–28

Sunshine In, 27

Supertramp, 88

"Surprise, Surprise" (song), 120

Sutcliffe, Phil, 44

"Swallowed Up (in the Belly of the Whale)" (song), 41

Swift, Taylor, 118, 129n2

Tarantino, Quentin, 89

"Terry's Song" (song), 114

Theisen, Gordon, 88–89

Theiss, George, 114–15

Theory of Justice, A (Rawls), 58

They Live by Night (film), 63

thick solidarity, 118

"This Land Is Your Land" (song), 64, 69

"This Train (Is Bound for Glory)" (song), 45–46

Thomas, Leslie Worth, 23

Thompson, Derek, 73–74

Thompson, Jim, 64–65, 89

Thoreau, Henry David, 85

Three Mile Island: nuclear accident, 63–64

"Thunderclap" (song), 113–14

Thunder Road (film), 63, 91

"Thunder Road" (song), 5, 29, 45, 114

Tillie, 21, 23, 128n1

Tilyou, George, 21, 23

True Grit (film), 128n1

Truman, Harry S., 78

Trump, Donald, 1–2, 19, 74, 76–78, 80–81, 102, 115; evangelicals, 79, 129n1; as non-denominational Christian, 79
"Tucson Train" (song), 106
"Tunnel of Love" (song), 23
Tunnel of Love (Springsteen), 23, 38–39, 63, 66–67
Turner, Frank, 119
Twain, Mark, 58, 85

underclass, 77
United Farm Workers, 68
United Nations (UN), 129n2
United States, 1–2, 11, 14–16, 19, 23, 34–35, 46, 62–63, 67, 77, 83, 85, 101, 111; American exceptionalism, 43; gun violence in, 129n3; homelessness in, 75; income gap, 13; individualism, 87; inequality in, 30–31; liberalism, 56–57; mass shootings, 70; poverty in, 74; as Promised Land, 43–44; self-reliance, 87; social fabric, unraveling of, 117–18; social mobility, 31, 128n2
Universal Declaration of Human Rights, 129n2
universalism, 55
Urban, Keith, 131n1
U2, 16, 129n2

Vance, J. D., 75, 80–81; as "cultural emigrant," 77; as unofficial spokesman for white working class, 76
Van Zandt, Steven, 90
Venezuela, 31
Vernon, Justin, 119

Victoria, Queen, 111
Vietnam Veterans of America (VVA), 66
Vietnam Veterans of America Foundation, 63
Vietnam War, 7, 130n3
Vote for Change tour, 68

"Wages of Sin" (song), 41
"Waist Deep in the Big Muddy" (song), 130n3
Walk Like a Man (Wiersema), 117
Wallace, William, 79
"War" (song), 66–67
"Wasted Days" (song), 114
Wayne, John, 62–63, 79, 91, 106, 108, 129n1
We Are One concert, 69
"We Are the World" benefit, 63
Weathervanes (Jason Isbell and the 400 Unit), 17
Webb, Jimmy, 18, 106, 110, 129n1
"We Can't Make It Here" (song), 71
Weiss, Larry, 111, 130n4
We Shall Overcome: The Seeger Sessions (Springsteen), 37, 100, 130n3; *American Land* edition, 99. See also *Bruce Springsteen with the Sessions Band: Live in Dublin* (Springsteen)
Western Motel (Hopper), 106
Western Stars (documentary), 107, 110
Western Stars (Springsteen), 2, 104, 106, 108, 110, 113
West Long Branch (New Jersey), 9

"We Take Care of Our Own" (song), 2, 14
"What Love Can Do" (song), 41
Where Have All the Flowers Gone (Seeger tribute album), 101
"Where's the Playground Susie" (song), 106
"White Beretta" (song), 17
whiteness, 83
Whitman, Walt, 85
"Who'll Stop the Rain" (song), 64
Wichita Lineman (Jones), 106
"Wichita Lineman" (song), 106, 110
Wild, the Innocent & the E Street Shuffle, The (Springsteen), 7, 114
"Wild Billy's Circus Story" (song), 111, 114
Wilkinson, Alec, 101, 130n3
Williams, Hank, 10, 71, 96–97, 104
Williams, Lucinda, 119
Williams-Chappel, Fiona, 107–8
Williamson, Kevin D., 77
Williamson, Michael S., 18, 74–75
Willman, Chris, 78
Wilson, Jackie, 2, 114
Wind River (film), 108
Winthrop, John, 43
Wisconsin, 15
Wister, Owen, 102
Wolff, Daniel, 23, 26–27
Wolff, Justin, 85

Wood, Grant, 85–87, 110
Wood, Nan, 87
Woody Guthrie Prize, 59
working class, 1, 3, 5, 11–13, 15–17, 21, 27, 36–37, 54, 58, 61–62, 70, 74, 76–81, 96–97, 129n1
"Working on a Dream" (song), 69
Working on a Dream (Springsteen), 98, 114
"Workin' Man Blues" (song), 97
World Health Organization (WHO), 129n2
World Trade Organization (WTO), 76
"Worried Man Blues" (song), 33
Wrecking Ball (Springsteen), 2, 14, 16, 19, 33, 41, 51, 61–62, 71; Great Recession, inspiration of, 13; musical styles on, 13
Wright, Frank Lloyd, 102

Yellowstone (television series), 88, 108
Youngstown (Ohio), 73–76
"Youngstown" (song), 61, 75
You Only Live Once (film), 63
"You're Missing" (song): as secular hymn, 53

Zanes, Warren, 65, 118, 127–28n2
Zhao, Chloé, 92–93, 108
Zimbabwe, 66
Zimny, Thom, 110

About the Author

JUNE SKINNER SAWYERS, born in Glasgow, Scotland, has written and lectured extensively on Bruce Springsteen. Her Springsteen books include *Racing in the Street: The Bruce Springsteen Reader*, *Tougher Than the Rest: 100 Best Bruce Springsteen Songs*, and, with Jonathan D. Cohen, *Long Walk Home: Reflections on Bruce Springsteen*. Her other books include *Celtic Music*, *Read the Beatles*, *10 Songs That Changed the World*, *Cabaret FAQ*, and *Bob Dylan's New York*. Her work has appeared in the *Chicago Tribune*, the *San Francisco Chronicle*, and the *TLS*, among other publications. In addition, she in an associate producer of *Voices over the Water*, a documentary on the Scottish diaspora.

About the Afterword Author

ANDRE DUBUS III is the author of *The Cage Keeper and Other Stories*; *Bluesman*; *Gone So Long*, and the *New York Times* bestsellers *House of Sand and Fog*, which was made into an Academy-Award nominated film starring Ben Kingsley and Jennifer Connelly; *The Garden of Last Days*; and the memoir *Townie*, a #4 *New York Times* bestseller and a *New York Times* "Editors' Choice." His most recent novel, *Such Kindness*, was published in 2023, and a collection of personal essays, *Ghost Dogs: On Killers and Kin*, in 2024. He is also the editor of *Reaching Inside: 50 Acclaimed Authors on 100 Unforgettable Short Stories*.

Mr. Dubus has been a finalist for the National Book Award, and has been awarded a Guggenheim Fellowship, the National Magazine Award for Fiction, two Pushcart Prizes, and is a recipient of an American Academy of Arts and Letters Award in Literature. His books are published in over twenty-five languages. He teaches at the University of Massachusetts Lowell.

Printed and bound by CPI Group (UK) Ltd, Croydon, CR0 4YY
03/12/2024